GW01367369

structure 107
suppliers 74
SWOT analysis, see strengths and weaknesses
targetting by sector 12
tax 57
tax, pay as you earn 61, 77
team management 103
team selection 32
teams 41
teams, changes 41
terms of business 27
The Times 1000 17
time management 116, 118
time stealers 121

timesheets 71, 72
trade publications 17
training courses 124

Unlisted Securities Market 58

value-added tax 60
variation/instruction sheet 43, 45
variety 95
VAT, see value-added tax
venture capital 58
visuals 36, 40
Who Owns Whom 17
working environment 123

Index 129

Index

Henley Forecasting Centre 17
hourly rates 65

income 64, 65
insurance 77, 78
integrity 13, 80
interest payments 65
Investors in Industry 58
investors 58
invoicing 27

job numbers 72
jobsheets 70, 72

Key British Enterprises 17
Keynote 17
Kompass 17

leadership 103
liability 27
limited companies 52, 56
litigation 78, 79
loans 58
loose-leaf diary systems 119

mail shots 18
management accounts 66, 67, 68, 69, 85
Marketing 17
Marketing Week 17
marketing 11
marketing by sector 13
marketing costs 65
markets, target 13
meetings 43, 104, 121
Mintel
minutes of meetings 43
models 40

net chargeable time 65
new business 84

office systems 123
on-line information services 17
order book 55

overdue debtors 82
overheads 57

partnerships 52, 53, 56
PAYE, see tax, pay as you earn
pensions funds 58
pitching 29, 30
portfolios 21
presentations 36, 109, 112
press releases 20
priorities 116, 122, 123
problem solving 122
professional indemnity insurance 77, 78
professional negligence 77
profit centres 93
project control 70
project directing 37
project familiarisation 34
project reviewing 37
project timetables 32, 33
project update sheets 73
promotion 13
promotion, indirect 19
public relations 19, 20, 80

recruitment agencies 76
reviews 37, 39, 104
RIBA, see Royal Institute of British Architects
Royal Institute of British Architects 19, 27
royalties 31

salaries 57, 65
second sell 48
secretaries 124
sector marketing 92
self management 97, 98, 99
selling techniques 18
shareholders 56
specialisation in design 91
specialisation in marketing 92
speculative work 30
staff 76
strategic planning 54
strengths and weaknesses 54

Index

administration costs 65
attitudinal responses 29

body language 109, 112
bonuses 57
bought-in costs 26, 27
brainpower 108, 109
brainstorming 108, 110, 111
briefing 37
budgets 64, 66
business plan 59

cashflow 82
cashflow forecast 82, 83
Chartered Society of Designers 19
checking systems 80
client education 36
client relationships 46
client types 12
communication 104
company registration 56
concept presentation 40
conditions of employment 76
conferences 19
confidentiality 80
confort zones 101
consultancy 46, 47
contracts 24
copyright 27, 30
credentials presentations 29
credit 74

CSD, see Chartered Society of Designers

DBA, see Design Business Association
debt collection 79
debtors 79, 82
decisions 121
delegation 37, 89, 105, 107
Design Business Association 19, 27
design press 19, 20
development, long-term 16
directories 17
divisionalisation 93
drawing record and issue register 43, 44

equity capital 58, 59
Euromonitor 17

factoring 79, 80
fee income 66
fee proposals 24, 25, 28
fees 25
finance 58
financial planning 64
forms 43
freelancers 52, 77
fundamental principles 7, 8, 9

goals 100, 101, 103, 104, 117
growth 89

handling charges 74

Meetings:
Set time to begin and end and stick to this. Use agenda (distribute in advance if possible).
Do not wait for late arrivals.
Agree a chairman – he must see all topics are given right amount of time, keep discussion on line and help reach conclusions.
Minutes should identify what action and by whom.

Making decisions – state apparent problems, get facts, state real problems, generate options, select, communicate rationale.

Large tasks – right frame of mind, break up task into manageable chunks.

Priorities – decide on priority and make room for it in your day. Fit in the suitcases first, then slot in plastic bags when find a little gap in the day.

Saying no – 'am I the right person for the task?' Delegate if possible.
Do not take interruptions (telephone, colleagues), if you cannot delegate, make a time later.

Working environment – keep a clear desk, only have in front of you the one thing you are working on. Stray papers disturb your concentration and cause stress.

Office systems – start with in-tray. Set up categories for action – do today, do this week, file, read, etc.

Secretaries – use adult-to-adult roles. Brief thoroughly. Do not abuse technology.

Training courses – time management courses available through:

Temple Millar
197 Botley Road
Oxford OX2 OHG

Time Manager International
50 High Street
Henley-in-Arden
Solihul
West Midlands B95 5AN

Business Time Systems
40 West Street
Marlow
Buckinghamshire SL7 2NB

Summary and Checklist

8.1 Attitudes

Priorities are essential. Pareto's Law – 80/20 relationship between time spent and results.

Creative avoidance – subconscious takes over. Others allowed to distract. Particularly where task is unpleasant or large.

Positive thinking – picture end result not task itself. Turn 'have to' into 'want to'. Use winner phrases, not loser phrases. Control your frame of mind.

Goals – energy comes from the mind, picture what you want and your mind will give the energy to achieve it.

Keep reviewing and renewing you goals – once goal is achieved energy is lost unless replaced with a new goal. Review short-, medium- and long-term goals appropriately.

Happiness is a state of mind – do not expect it to come with the achievement of the goal alone – it is better to travel hopefully than to arrive.

Be a creative adventurer like you were as a child – it is amazing what you can achieve when you don't know you can't.

8.2 Tools

Loose-leaf systems have advantages over conventional diaries. What and when on one page for each day helps you plan and balance appointments and task. Set priority task(s) for each day and an achievable number of tasks overall. Set aside time for yourself to undertake priorities.

Improvement on one long list. Able to spread tasks over period of time and only have to look at those you are immediately able to tackle.

Other notes and thoughts can be written down in other appropriate sections of your loose-leaf system. Open sections for your main areas of responsibility.

Month-to-view diary gives overview for appointments and opportunity to highlight long term, major tasks.

8.3 Techniques

Time stealers – write them down, discuss them with your colleagues. Attitude change for designers from doing to managing – more emphasis on communication, delegation, etc.

SECRETARIES

Whether you have a secretary of your own or share one with colleagues, they are an invaluable help if used properly. Like all other relationships in the company you will get the best reaction and response from your secretary if you employ ADULT to ADULT attitudes.

Whenever you ask her to do something, brief her properly – delegate the task completely and thoroughly. There is nothing more irritating than having to do things twice because you are not given the whole story first time.

One good way to check that you have delegated effectively is to ask her to repeat to you what it is she thinks you have asked her to do!

Word processors are such an asset when the report needs changing at the last minute and you want six originals straight away. However, because they make life so much easier they often lead to abuse. It has become so easy to change things you do not take so much care the first time – so in fact you waste time instead of saving it.

TRAINING COURSES

While this book gives you the principles of design business management, you may find you would like to take some of the aspects a little further. In particular, the theory of time management is quite a difficult notion to get your mind around and you may find it easier to spend a couple of days on a course, going through it in detail and having someone to talk to about it. 'Time Manager' and 'Business Time Systems' will both give you a similar grounding in the theory of time management.

Do not feel that the ideas of time management, self management and team management are too disciplined for you and that they will curb your natural instincts. Rather they will help you achieve those goals and tasks you want to and give you more time for other interests, informal or social time, and more confidence to move forward to new goals in your life as a whole.

Set your mind right and you will enjoy your business life and your private life to the full.

you can undertake when you have a moment between meetings.

There may be some things you just cannot get done at all. As long as you have set your priorities correctly, the items that do not get done should be relatively unimportant tasks and you will often find that these may even solve themselves.

SAYING NO

As part of organising your tasks into priorities ask yourself whether you are the right person for the task. Do not automatically do everything on your list, think about whether you could delegate the task and get on with something more important.

Similarly, when a colleague interrupts you or the telephone rings while you are in a meeting (even if the meeting is with yourself), learn to say 'no'. If you can, delegate. If you cannot delegate, make a time later in the day to deal with it. You do not have to be rude when saying no, but be firm.

WORKING ENVIRONMENT

Just as you can only concentrate on one task at a time in your mind, try to keep your desk clear of everything except the task you are working on. Stray thoughts in your mind will disturb your concentration, stray paperwork on your desk will have the same effect.

A clear working environment is even more important than just helping you concentrate. It helps you stay sane. In the same way as you react to a long unprioritised list of tasks as a constant reminder of the volume of things you have to do, so you react to a constant pile of papers in front of you reminding you of other projects waiting in the wings.

The build up of reminders of a volume of work and the lack of organisation of your lists and papers will cause immense stress and ultimately ill health. You will be constantly worried and will not be able to enjoy your work.

OFFICE SYSTEMS

In order to avoid the stress that can be caused by paperwork, set up a system for dealing with it. Start with an intray where all incoming post, messages, magazines and so on are put. People should not put things straight on you desk. You must empty your intray regularly though, otherwise people will see you do not check it and will jump the system by putting things on your desk again.

Next you can generate your own categories for paperwork such as:

DO TODAY	PASS TO OTHERS
DO THIS WEEK	TO SECRETARY
FILE	PROJECT A
READ LATER	PROJECT B

It does not matter what words you use or what physical containers you have to put your paper in, so long as it works for you.

50's Britain was considering how it could best improve communications with the Commonwealth. The apparent problem was that intercontinental jets could not land at many of the major airports around the Commonwealth. So the V.C.10 was designed to take off and land on short runways.

However, concrete turned out to be cheaper than designing a new aircraft. By the time the V.C. 10 was operational the real (as opposed to apparent) problem had been solved and many of the runways were lengthened. This meant that the Boeing 707 could land on them and, because it was a more efficient aircraft to operate, many more 707s were sold than V.C.10s.

Problem solving, whether by an individual or a team, can be unnecessarily time consuming if the approach to it is not ordered. If you follow this technique you should save time and produce better results:

a. State apparent problems

b. Get facts

c. State real problems

d. Generate options

e. Select

f. Communicate rationale

LARGE TASKS

As illustrated earlier in the case of the designer writing a report, large tasks can lead you to creative avoidance and time wasting. Getting yourself into the right frame of mind is very important for tackling large tasks, but sometimes a task is so large you have to do more than that.

Tasks that are so big that they take weeks to complete, or so large you cannot see the end of them – cannot picture yourself finishing them – need to be brought down to size. You must break such tasks up into manageable bits and set your mind to each piece in turn.

Your mind can then cope with the task – and therefore you can. You will also be spurred on by the energy of setting, achieving and resetting goals. This was how the Great Wall of China was built, in 20-mile sections – l50 of them making up some 3,000 miles!

PRIORITIES

Decide which tasks are priorities and make sure you have room for them in your day. Imagine you are packing up the car to go away on holiday. What would you put in first? The suitcases or the little plastic bags full of late remembered items and things you want to keep handy.

Of course the suitcases have to go in first they are the most important items, you could not afford to leave one of them behind.

The plastic bags can be squeezed into those little nooks and crannies that always seem to be left once the suitcases are in place.

Break up your tasks into suitcases and plastic bags. Make time and set times for the suitcase tasks, but keep a note of the plastic bag tasks that

8.3 Techniques

An interesting and worthwhile exercise is to write down your 'time stealers' – what it is that seems to steal away those precious moments until eventually the whole day has just disappeared. Share this exercise with your colleagues too – you may find you appear on each other's lists as a cause of lost time, which in itself should lead to useful discussion about how to avoid this in future.

You will probably find that most of you share many of the same time stealers – meetings, telephone, interruptions, your boss, your subordinates, delegation and personal disorganisation. Some of these may be to do with your attitude towards your job.

Designers who have spent their working life at the drawing board and dealing with clients will often find it difficult to switch over to a management role. In most design businesses the switch is very gradual anyway and so the management tasks – communications, delegation, and so on – will initially seem like interruptions to the job of designing.

This is something you will have to get to grips with and help others do the same. The more senior your position in the company the more your job will switch from DOING to MANAGING.

Many of the time stealers you identify, however, will be real ones and there are techniques you can use to improve the situation. Below are some useful techniques for some of the most frequently experienced time stealers.

MEETINGS
Always set a time to begin and end the meeting – and stick to these times. Distribute an agenda in advance if possible so that everyone is prepared. Use an agenda even for informal meetings – set aside the first couple of minutes of the meeting to do so. Do not wait for late arrivals but carry on with those who are there – if your meetings is with one other person and he is late, carry on with something else rather than sit around waiting for him.

Someone should chair the meeting and be responsible for seeing that all topics are given the right amount of time for discussion. The chairman's role should be to help the rest of the meeting reach conclusions, so if he feels the discussions are wandering he should guide them back on line.

Notes or minutes of meetings, however informal, should clearly identify who is to take what action. If there is no apparent action to be taken following a meeting you should question why the meeting took place.

Set meetings with yourself as well as others – in other words, block off time in your diary when you will do some thinking, resolve some problem or undertake some task.

MAKING DECISIONS
Very often we spend needless time and effort trying to solve the apparent problem. Back in the

do not book yourself up all week with meetings just before going away but can pace yourself over the weeks much more evenly. It also gives you the opportunity to highlight one or two major tasks which you want to achieve that month, so you can start to book in time with yourself to get the tasks done.

The system is not everything but if you feel the principle of time management is good then you should find the system a great help. One word of warning, though – do not expect to change to a new system and feel comfortable with it on day one: it is likely to take you a few weeks or even months to settle the whole system down in a way that suits you best and is really tailored to your life.

8.2 Tools

Conventional diaries are more and more being replaced by loose-leaf systems. Some are very like conventional diaries with a filing section at the back and a few pages for notes. Others have developed the system a little further to provide you with a daily plan. This enables you to integrate what it is you have to do with your fixed appointments (see fig. 11).

One advantage of having the 'what you have to do that day' on the same page and the 'when your appointments are' is that you can immediately see the balance between meeting time and time to achieve tasks. This allows you to set yourself an achievable number of tasks each day – and therefore a degree of satisfaction at the end of the day.

Another aspect of this type of system is that you can identify a specific time during the day to keep for yourself during which you will undertake the priority task of the day. Looking forward through the days, it is much easier to judge when you are likely to have time to complete a task given your other commitments. Once you have decided when you will do it you can write the task in on that day and forget about it till then.

This is much better than writing everything down on one long list which you have to look at all the time. Even with the aid of coloured highlighter pens, it is extremely difficult to see what the priority items are, In addition, every time you look for the next thing to do you are faced with the full length of your list – which can be enough to cause anyone a mental breakdown.

The time management diary pages have another advantage over the list in that not only are you dividing up your tasks into time segments, but you have the facility to set priority task for each day and other smaller tasks and telephone calls. All of this leads to clearer thinking, less panic and greater efficiency.

In addition to the diary pages the loose-leaf systems gives you the opportunity to bring all your thoughts and reminders for all the key areas of your business, home life and personal development into one system. So if you have random ideas you are not sure what to do with immediately – have a section for such ideas so you can go back to them later. If you are responsible for new business, open a section for that and put any thoughts about potential clients into there.

This way you need never forget anything and never have to worry where you put that scrap of paper with that really good idea or useful telephone number written on it.

Finally, many loose leaf-systems have a month-to-view diary. This tends to give you only a very small area to write in your appointments, but enough to know who you are seeing and when (more information can be recorded elsewhere as appropriate). The great advantage, though, is that it gives you a tremendous overview – so you

enjoy both the journey and the end result. You need to be a creative adventurer like you were as a child – it is amazing what you can do when you do not know you can't.

better to break it into sections and set himself each section as a goal. Then each time a section is completed he has a sense of achievement which will help him move on to the next goal – the next section.

Positive and negative thinking also affects our performance. If the designer is thinking about how he hates to write reports this will impair his ability to perform well. He should not attempt to persuade himself he is going to enjoy the task itself for he would soon be disappointed. However, if he affirms that he writes a good report and that he can see himself having finished it being congratulated by the client who then confirms the new project because of it, then he will be in the right frame of mind to perform well.

How you see yourself and 'talk' to yourself is all important in this. All of us have the potential but only some of us really use it. Self doubt and fear are the biggest obstacles to success. You must learn to recognise loser phrases and replace them with winner phrases. Here are some examples:

LOSER PHRASES	WINNER PHRASES
I was unlucky	I could have done better
Others are worse than I am	I could improve
That is none of my business	Maybe I can help
You did not ask me to do it	I should have noticed that

Self management, frame of mind and affirmation of projected achievement of goals are all important in developing a winner mentality.

Goals are important because energy comes from the mind. When you have a picture in your mind of what you want, it gives you energy to get there. Once the goal is achieved, however, the drive and energy is lost unless you replace it with a new goal.

Working on a project you have a great deal of drive and energy picturing the end result in your mind. However, when the project is over you experience a drop in energy levels. It is the same whenever you do not have a clear picture of a goal in your mind – falling asleep when you get home, wasting the first hour at work and so on.

So it is very important to review our goals and to move them regularly. Remember that your goals will be short term, medium term and long term so you will have to use different review periods for each category.

Happiness is a state of mind. We constantly need new goals for energy, but the goals themselves must not represent the attainment of happiness. Do not think 'I will only be happy when I achieve my goal'. Life is too short and too precious for that. As the Chinese say, it is better to travel hopefully than to arrive.

If you pin too much expectation on the goals themselves you will surely be disappointed when you achieve them. But if the setting of goals and the framing of your mind are used well, you will

Chapter Eight

Time Management

8.1 Attitudes

Priorities in business are essential. Without recognising priorities you will not achieve the goals you set yourself and your team. There are tasks you should spend more time on and others you should spend less on. It is very important that you differentiate between these.

Pareto's law suggests that a manager spends 80 per cent of his time producing 20 per cent of the results and 20 per cent of his time producing 80 per cent of the results. Your ambition should be, even marginally, to increase the 20 per cent of your time that is more productive in order to bring you a disproportionate level of achievement.

One of the problems we have is that priority tasks are not necessarily pleasant and we try to avoid doing unpleasant things. In fact we are very creative in our avoidance. Even worse, we may not recognise this creative avoidance at all as it is mainly a subconscious activity.

Take the designer writing an important report. He knows it must be done but he does not like writing reports. So two minutes after sitting down to write it his bladder starts feeling uncomfortable so he gets up to go to the toilet – it may only be twenty minutes since he last went but the feeling is real enough. On the way back to his desk he decides he really needs a cup of coffee. Once at the coffee machine he starts talking to a colleague, but eventually goes back to his desk. Two more minutes go by and he thinks of something he wants to check regarding another project. Instead of jotting down a note and coming back to it, he gets on the phone.

A few minutes more on the report and someone interrupts him to ask him something ... and so on. The longer this goes on the more difficult he finds it to get into writing the report. The problem is he sees it as something he has to do rather than something he wants to do. If he focused on the end result – getting a new project as a result of the report – rather than the writing of the report his attitude would have been far more positive.

In addition, if he found the task of writing the report too large to cope with, he would have been

'Tell them what you are going to tell them'
'Tell them'
'Then tell them what you have told them'
Finish clearly and strongly.

Take questions – thank questioner, check you have answered his point. LISTEN to questions carefully and keep your answer on line.

Ensure action by identifying who should do what and by getting final agreement.

Each team member is an individual – treat them so. Establish individuals' wants, needs, expectations, aspirations. Ensure they all have valid roles.

Use job descriptions for permanent teams. Establish clear roles and responsibilities for each team member.

Set goals. Consult with team. Be prepared to adapt goals

Set your goals against an appropriate timescale (not deadline). Communicate conclusions to your team. Set the team's minds on action and affirmation.

Formal communication: regular update meetings and individual reviews.

Informal communication – individual attention (even negative better than none at all). Play adult roles rather than parent or child. Use the first 4 minutes to good effect.

Create opportunities to spread good news.

7.4 Development of Individuals and Teams

Delegation – delegate completely, formal responsibility must be accompanied by real authority

Ask yourself whether you could delegate more.

Organisational structure – no one should have more than 45 people reporting to them directly. Relationship of fee earners to others should be around 2 to l.

Brainpower – use both left and right sides of brain, (e.g. brainstorming = right then left). Use brain patterns to develop thoughts (individual and team). Write thoughts down immediately. In meetings use right-hand margin for your thoughts.

PRESENTATIONS

Ensure audience hears, understands and enjoys everything you say.

Use your voice

Do not mumble

Vary volume and pitch

Slow down

Use pauses to highlight

Use body language

Hands and arms for bold, confident gestures and emphasis

Avoid distracting movements

Use eye contact on all in audience for respectful period of time.

Structure – introduction, main body and summing up:

Summary and Checklist

7.1 Self Management

Learn to guide yourself without the help of others. Being side-tracked and wasting time leads to a sense of frustration and failure. Stress is caused by what you do not do, not what you do.

Business today emphasises effectiveness, performance and using potential. Start with individuals and work out to colleagues, clients, suppliers.

Balance your work and private life.

Effective self management requires practice. It starts with organising yourself, your time, your aspirations, your thoughts and feelings – get them into shape.

Give yourself time and space. Know yourself. Who am I? Where do I stand now? Likes and dislikes, strengths and weaknesses.

Build on strengths. Turn weaknesses into damage-limitation areas.

7.2 Goal Setting

Establish what direction – what aims, what goals. Short, medium and long term goals. Vary goals from easy to tough – never set impossible goals.

Goal comes first, then how to reach it. Set start date and plan of action – avoid deadlines (turns a 'want to' into a 'have to').

Review goals constantly – DO/ASSESS/PLAN NEXT STEP/DO AGAIN.

Move gradually to new, higher, wider and more challenging comfort zones.

Use mind power rather than will-power. Start to change your beliefs about yourself. 'That's not like me, I can do better than that'.

7.3 Team Management

Establish your team, their strengths and weaknesses, and what goals you wish to achieve as a team.

Establish principles of leadership – attitudes towards your team, company's attitudes towards staff generally, responsibilities and duties towards your team.

Leadership by example, instruction, encouragement, respect, fairness, commitment, sensibility.

One key issue in the use of body language is eye contact. Do not stare at the floor, use your eyes to involve your audience. Look straight at individuals – not the same ones all the time or they may become nervous. Try to look at everyone throughout your presentation to involve them all, but do not skip from one to another – give each one a respectful amount of time.

With regard to the structure of a presentation, or any talk, plan what you are going to say and let your audience know. In simple terms you should break the presentation (or each major section of it) into three parts – the introduction, the main body and the summing up. An easy way to remember this is:

'Tell them what you are going to tell them'

'Tell them'

'Then tell them what you have told them'

Whether you sum up at the end or just find a good way of rounding up, make sure you end clearly and strongly – do not just peter out.

Take questions – these help you clarify points to the whole audience. Encourage the questioner by thanking him, checking that his question and your answer satisfy the point he has raised. Make sure you LISTEN carefully to questions and keep your answer on line.

If you want some action to come from your presentation (and you normally would) it is up to you to raise this subject, identify who should do what and get final agreement to the action proposed.

ariety

——— don't tail off at end

h, Pause, Pounce ——— Read / talk / read

iority ⟵ words 10%
 tone 40%
 body language 50%

Greeting Name Subject Aims ⟨ Open ⟨ features
 benefits
 Hidden

 Introduction ⟨ Areas
 Time
 Questions — when + benefit

Structure

 Main body — areas in order

 Summary — precis

 Action — Audience

Figure 10: an example of brainstorming

thoughts on the paper going in different directions, whereas the list gives no indication of direction of thought at all – merely a chronological sequence.

Finally on brainpower, get into the habit of writing thoughts down immediately. If you are in a meeting and taking notes on a pad, leave the right-hand quarter of the page free. Use the majority of the page for minutes or notes of the meeting, but keep the right-hand margin for notes to yourself. Any thought you have, jot it down on the right – this may be something you want to remember to bring up later in the meeting, or something totally irrelevant to the meeting that you want to pursue later.

When you are not in a meeting, keep an pencil and paper handy – there is nothing worse than knowing you had a good idea and not being able to remember what it was.

PRESENTATION

Presenting well can be critically important to a design business. Concept presentations and their format have already been covered, but the manner of presentation, the planing of the content and the rapport with the audience are all critical.

Your aim in a presentation of any kind is to ensure that your audience hears, understands and if possible enjoys everything you say. In order to achieve this you must concentrate on more than just the content.

It is not in fact the words you speak when presenting, but the way you use your voice and the body language you employ that make or break a presentation.

This may seem at first to be rather a surprising statement because of course the words or content are very important. However, if your audience do not hear what you are saying because they have fallen asleep or their minds have drifted away to think about something else, then all your efforts to say the right things will have been wasted.

Designers often have the advantage of presenting visual material rather than just ideas in words. This certainly helps to maintain the audience's attention, but you still need to use your voice and body to good effect.

Starting with the voice, do not mumble but rather speak up with authority. Vary the volume and pitch of your voice, avoid dreary monotone. Slow down and give your audience time to reflect on what you are saying. Use pauses to highlight important points – just before and/or just after the point in question – and make the pause longer than you think (although you will feel uncomfortable at first, it is possible to pause for up to 20 or even 30 seconds without losing your audience).

Body language is extremely important too. Use your hands and arms to make bold, confident gestures – particularly to emphasise important points. However, you should avoid distracting movements such as folding and unfolding your arms – i.e. any movement that is not keeping with what you are saying.

in place, each manager should be able to keep to this relationship.

It is important to notice the difference between 'reporting to' and 'relating to'. Every position will relate to many more than four or five others in a wide variety of ways. However, 'reporting to' refers to a direct boss-to-subordinate relationship where the boss is directly responsible for the performance of the four or five subordinates and will take decisions on hiring, firing, promotion, and salary within the framework of his own authority.

Relationships and numbers of designers in studio teams will depend very much on the company's approach to the business. A creative consultancy will need more chiefs and fewer Indians than a company doing repeat implementation work of any kind.

The relationship between fee earners (usually designers) and support staff is certainly one to watch. With experience you should be able to recognise the right balance of these two categories for your company. As a rule of thumb, the fee earners should not drop below about two-thirds of the overall head count.

BRAINPOWER

The next area of management techniques is to do with better use of brainpower. Your brain tends to work in two ways – logically and creatively. While the two are not mutually exclusive, they use different sides of the brain and can restrict one another if not controlled.

The left side of the brain deals with logic, sequences, words, numbers, common sense and analysis. The right side thinks in pictures, humour, spontaneity, feelings, body expression, and play.

Designers will tend to have a strongly developed right side – which, incidentally, controls the left-hand side of the body, explaining why an unusually high percentage of designers are left handed. To make the most of your brain power you need to learn to use both sides of the brain.

Brainstorming is an example of using both sides effectively. The process takes place in two parts – first using the right side of the brain to create ideas in a sporadic and spontaneous way, and then using the left side to analyse what you have come up with. If the left side is brought to bear too soon it will constrain the development of ideas.

Interestingly, designers often have difficulty, not in coming up with ideas, but in analysing what they have got and how to develop it to a logical conclusion.

A technique for individuals or teams to use for brainstorming is that of 'brain patterns'. With this technique you start with a key word in the centre of the page and put down thoughts literally branching out from the centre for an example, (see pages 110–111). If you let the right side of your brain run free you should end up with a very wide variety of thoughts that are unlikely to have missed any avenues.

The process works much better than writing down a list because it is easier to spring off

7.4 Development of Individuals and Teams

Apart from management for goal achievement and communications, there are some other management techniques you will find useful. These include delegation and structuring the business, lateral-thinking techniques, presentation techniques, priority setting and time management. (The last two are dealt with in Chapter Eight.)

DELEGATION

Delegation seems like a great idea when you are busy because you think that it will take a huge workload off your shoulders instantly. When you try it and you still seem to be as busy, you conclude that nobody else can do anything as well as you can, and that's why you still have to do it for them and why you are still too busy.

If this happens to you, stop and take a good look. The chances are you have not delegated the work properly. The most common fault is to delegate insufficiently – in other words, you are getting someone to do part of the job instead of the complete task. In this case, each time they come to the end of what they can do they have to refer back to you for more information – thus taking up your time, and also wasting their own if they have to wait for you to be available.

A similar problem arises when formal responsibility is delegated without real authority. Here, they can get on with more of the task but still have to come back to you for authority to continue, or for decisions on which way to go next. When you delegate a task, consider whether you have also delegated the decision-making powers to get it done!

Other difficulties arise when the person you have delegated to does not have the knowledge or experience to do the job – but here you have the chance to develop his skills to tackle it properly in the future. Also, you may have delegated to the wrong person in the organisation – their terms of reference and lines of communication may interfere with their ability to do the job effectively.

Finally, it may be worth asking yourself whether you have really delegated at all. You may still be involving yourself in a level of detail that is no longer necessary for you to handle personally, but are finding it difficult to give up old habits.

STRUCTURE

Restructuring to take account of changing circumstances – usually growth of the company – is often a very difficult thing to get right. There are no hard-and-fast rules because every company in every line of business is different. No two design businesses even will approach this problem in the same way.

There are a few guidelines, however, which may be of assistance. No-one should have more than four or five people reporting directly to them. The team may be a great deal larger, but so long as an effective middle management structure is

foot according to how you deal with the first four minutes. People react to you according to how you are with them.

If you come into work in a bad mood and walk all over people they are likely to be unhelpful to you all day. If you are reviewing a project and destroy it and the designer who produced it in the opening sentences you will find that he/she has switched off by the time you are being constructive in your comments and want him to listen. Pick up on the good points first (even if you find them hard to pin down!) so at least you still have an audience when you tell the designer to start again.

Finally, create opportunities to spread good news. Have team meetings or social events at the end of a day from time to time to celebrate winning a project or some other event. Pass on information you are aware of but others are not which would be good for morale – how the company is performing, growing, winning business and so on.

different to formal meetings and reviews, is that the individual team member is not aware of any planned intent only of the positive aftermath.

As individuals we all want attention. Each team or each company is like a family unit. The individual designers are the children and the team leaders or company directors the parents. Giving children a pat on the back – physically or mentally makes them feel very positive. Telling them off makes them feel negative – but done in the right way can still be motivating. The worst thing for a child is not to be given any attention at all.

So keep in touch with your team, make them feel wanted and noticed – it is very important to them. It is equally important to you to keep in touch so that you are constantly updated with events, both small and large, and this can be done by walking around, chatting and generally making time for your staff.

The parallel between business and family relationships is a useful one but at the same time dangerous. It highlights the natural tendencies of the various parties but not the way to get the best out of each other.

If directors act like parents they will tend to dictate rather than delegate and therefore compound the individual designer's feeling of playing the role of a child. The designer as child wants everything, wants it now and wants someone else to make it happen – in other words expects to take no responsibility for making things happen.

The most positive relationship between director and designer is where both are playing adult roles. Here, there is mutual respect and shared responsibility. This in turn allows for true delegation to be carried through successfully and a healthy atmosphere of co-operation to exist.

To illustrate this with a simple and yet typically irritating example of office life, here are three ways of asking someone to get you a cup of coffee:

PARENT Get me a coffee

CHILD Oh please get me a coffee would you. Just for me. Oh go on, I'd really love one.

ADULT Would you please make a coffee for me so that I can make this phone call before going into the meeting.

We all have the ability to play any of these roles. Most of the time we play whichever one is most natural to us or we may change roles because of our mood. We do not tend to think about the reaction we will invoke.

Parent roles tend to invoke child reaction and vice versa. It is in your best interest to have people react in an adult fashion and the way to achieve this is to play an adult role yourself when dealing with them.

Another point of communications is that you can set a situation off on the right or the wrong

future. Refer to the philosophy and approach to the business (see Chapter1) and allow for this in the goals you set.

Goals you set might be linked to specific projects (time to be allowed for experimentation; opportunities for junior designers to learn) or to the day-to-day running of the business (subjects for training to be developed and implemented; ambitions and budgets for the coming year; remember to do your time-sheets on Monday mornings).

Once you have set your goals, consult your team. Discuss the goals and be prepared to change or adapt them following your team's input into the discussion. Then come to decisions about your goals and set them against an appropriate timescale (not deadline) – finally communicating the conclusions to your team so that they are clear and motivated to start setting their minds on action and affirmation.

In order to maintain direction and momentum you will need to communicate with your team and motivate them on a regular and formal basis as well as taking every opportunity informally to reinforce the message.

In terms of formal communication this will probably fall into two categories – regular update meetings and individual reviews. Update meetings should not take place for their own sake but only when there is a purpose. It is easy for meetings to be set up in the first place because they are thought to be a good idea and then to become an institution in their own right long after anyone can remember why they were originally called. But so long as something positive comes out of them, they could remain in place for years.

If meetings are limited to relevant personnel, are planned with an agenda and a time limit, and are well controlled, then they can be very useful. Do not waste each other's time in meetings. If there is something that needs to be read by everyone in order to discuss it, circulate it first, before the meeting, so that everyone is prepared. If someone is late, start without them – it is better that one person misses part of the meeting than everyone sits around doing nothing for twenty minutes.

Individual reviews have a very different purpose. They are not update meetings of a day to day nature, they are an opportunity to review performance, plan the future and review the goals and aspirations of the individuals. It is also an opportunity for that individual to comment on the team, the company and the direction of the team and/or company. Reviews should take place at least twice a year and may be worthwhile on a quarterly basis. These review meetings should be kept quite separate from salary discussions or both sides will start to see them as purely discussions on performance and related financial reward.

Informal communication and motivation can take a large number of different forms. The common factor, and the thing that makes them

7.3 Team Management

As with self management the first thing to do is to establish who your team are, what the strengths and weaknesses of the team are and what goals you wish to achieve as a team. Then, in terms of how to achieve those goals, you can review your communications, delegation, structure and approach.

Your team may be a part of a company or a whole company. You may be helping establish goals for a series of teams. You may be leading a team permanently or just for a period of time on a project. You may in fact have different teams working on different projects at the same time.

Whatever team you have defined, you must establish some principles regarding leadership. What attitudes do you have towards your team and what attitudes does the company have towards its staff in general? What are your responsibilities and duties towards your team? What sort of leader do you intend to be?

Leadership consists of various elements which come into play in different ways, at different times with different members of the team. Leading by example, leading by instruction and by encouragement, being respected, being fair, showing commitment and sensibility.

Each team member is an individual and will respond in different ways to stimuli. Where one person needs to be encouraged to speed up another may be rushing at it, one person may react well to a firm telling off, another may go to pieces.

Recognising the different strengths and weaknesses of individuals in the team and using them to get the best out of your team is one of the essentials of good leadership. On the other hand you must not be ruled by your team either – do not spend all your energy keeping your team happy but fail to achieve the goals. It is your team's respect you need, not their friendship – and they will not think much of you or themselves if as a team you fail to achieve your goals.

Next you must find out what the individuals want, need and expect from their involvement in the team and their aspirations for the team as a whole. Build the relationship with the individual members of the team. Ensure they all have valid roles, that you need them all – then make the best of them all. If the team is relatively permanent you will find it helpful to set down a job description for each person who reports directly to you and get them to do this in turn for their subordinates.

It is essential that everyone is clear about their role and responsibilities, that they know what is expected of them in detail as well as in general terms.

In setting goals for the team follow the same practice as outlined in self management. Look at where the team is now, its strengths and weaknesses, and what plans or aims it has for the

way they become established in the first place — by affirmation. Mainly you will have to rely on yourself to affirm these beliefs but if you involve appropriate colleagues and friends in the process they can provide additional support.

If you do something badly there is always the temptation to say 'that is typical of me'. You can hear the voices of your friends 'Oh you are always doing that' or, in advance of anything going wrong, 'Be careful now, you know what you are like.'

You have to turn all that around. Start to say 'That is not like me, I would expect to do better than that.' Start to put a more positive light on yourself and share your more positive view with those around you. But when praising yourself be sure to do it quietly. You can obviously praise others out loud but work on yourself quietly.

Finally, do not use excuses to get round it. If you fail to do something well, do not blame a colleague or the tools you were using. If you fail to get a point across to someone, rather than intimating that the other person is a fool, say to yourself 'I could have explained that better, I did not make it clear.'

Another way of putting this is 'I own the problem'. It is not somebody else's problem and therefore to be ignored, it is your problem to be tackled and solved by you.

DO
|
ASSESS
|
PLAN NEXT STEP
|
DO AGAIN.

This way you can move towards a goal, achieve it and set a new goal. You will feel more and more confident as you achieve goals in small steps and move on to new ones. Set the goals too far ahead or with an unachievable or uncomfortable deadline and you will produce a negative reaction. The motivation must be positive and enjoyable, not negative and fearful.

Each of us have comfort zones. At a certain level of achievement or responsibility, with a certain level of income, in certain company we feel comfortable. Given a situation in which we are faced with more or less than we expect we feel uncomfortable and will work hard to get back into our comfort zone.

In line with gradually achieving our goals, however, we can at the same time move our comfort zones. This happens with companies as well as individuals. If you win a large project you did not expect to win at your stage of development or your size of company you will probably feel uncomfortable and nervous until you can adjust your comfort zones to match the reality of the situation.

By constantly reviewing your goals you will move yourself into new, higher, wider and more challenging comfort zones.

Start with a few goals that are relatively easy to accomplish to get yourself into this way of thinking. Then set down any specific action you can take to help move towards achieving the goal. In addition to action you will need to put yourself in the right frame of mind. You will need to affirm to yourself that you are comfortable about the idea of achieving the goal, that it is quite attainable and that you can see yourself having achieved it.

You need to call upon the power of your mind. This is much stronger than will-power as it is based on belief rather than thought. The mind, particularly the subconscious mind, is incredibly powerful and can enable you to achieve things you had not thought possible. The hypnotist uses this power for example to persuade your subconscious mind that you are very strong when getting you to lift a great weight above your head. Again under hypnosis you may be persuaded that a pencil is a cigarette and, when the pencil touches your skin, a blister will form.

Hypnosis is a very quick way of accessing your subconscious in order to change your beliefs. You can, however, achieve similar effects over a period of time by goal setting and affirmations – picturing your future as you want it to be.

Most of us start life with much the same potential to achieve aims but over the years have told ourselves or been told by our family and friends that we can or cannot do things, that we are good at some things and not at others. We have the ability to change these beliefs in just the same

7.2 Goal Setting

Knowing yourself, your strengths and your weaknesses, gives you the current framework and helps you see clearly what parts of your make up are likely to help you move forward and what elements may hinder you if allowed to. You now need to establish what direction you want to move in.

What aims do you have? What goals would you like to achieve? Write down a list of goals for different areas of your life – your work, your home, yourself – and try to achieve a balance.

Also vary the time span for these goals. Break them down into short term (this week, this month), medium term (six months, one year) and long term (two years, five years). Vary the goals from relatively easy to tough – but do not set 'impossible' goals or you will simply be setting the scene for failure and disappointment.

The goal comes first – then see how to reach it.

Many people want to see the route map to their goal before setting it. If you can see how to reach your goal at the time you set it the chances are, it will not be very challenging. It is not until you set a goal that your mind is set to pick information that will help you get there. What do you want for yourself? Recognise the opportunity, then see the problem. This will lead you to seeing the solution and being able to move towards and eventually achieve the goal.

Goals can be quite practical and have a tangible end result – for example to write a strategic plan for your company or your part of the company. On the other hand they can be more abstract – such as to become a confident presenter.

Whatever the goal, it should be set against a start date and a plan of action. The action will identify ways of overcoming the problems and achieving the end result. Specific actions may be identified as taking place at specific times, but do not set a completion date for achieving your goal unless you really must.

The reason for this is that deadlines are selected at the same time as you set the goal. This means that you calculate how long a goal will take based on your current information. But until we set a goal and then start scanning our environment for information to get us to it we will be unaware of an awful lot of information that will help us get there. In other words we are excluding the possibility of doing it earlier.

Most goals you set yourself, as opposed to projects set by others, will not have essential or integral deadlines. Setting deadlines turns a 'want to' into a 'have to' thus changing your attitude towards the goal. Keep your goals as 'I want to...' and you will be more successful in achieving them because you will think more positively about them.

Keep goals up to date by reviewing them regularly so that you take yourself through a cycle of stages:

and where do I stand now?' Finding out where you are now will enable you to project forward and see how to start moving in the direction you want.

Get a pen and some paper and write down your likes and dislikes in relation to work and home. Doing it in the form of a chart, as shown below, will help you see them more clearly.

	LIKES	DISLIKES
Work		
	Doing visuals	Writing minutes
	Working drawings	Presenting
	Etc.	
Home		
	Eating, drinking	Washing up

Then do a similar exercise putting down your strengths and weaknesses in terms of various factors – attitudes and habits, health (mind and body), sensitivity, self-esteem and image, ability to communicate, knowledge and professionalism, skills, decision-making, problem-solving and so on. Again the next chart shows some examples of this.

FACTOR	STRENGTH	WEAKNESS
Attitude	Careful	Lazy
Health – mind	Concentration	
Health – body		Unfit
Sensitivity	Care for others	Easily upset
Self-esteem	Good at job	Respect of others
Communicating	Good written	Poor verbal
etc	etc	etc

The build up on the two charts is beginning to give quite a clear indication of the person – in this case apparently a solid, working, careful designer who lacks confidence in projecting himself in presentations and to his colleagues.

Once you have put down on paper where you are now you can start to select areas where you have strengths, feel good about them and build on them, and turn the weaknesses into 'damage-limitation' areas. You will not be able miraculously to turn weaknesses into strengths overnight but the overall movement will be in the right direction and each step will make the next step possible.

Take care your business life does not take over the rest of your life. Enjoying your business is very important, but it is equally important to achieve some balance. Keep some time and some energy for your family, friends and interests. Self management is to do with your whole life – the sense of failure is just as bad if you fail to keep your private life going, if you never get round to things you wanted to do at the weekend, if you fall asleep at dinner or fail to turn up because of a late business meeting.

The worst combination arising out of a lack of self management is when you allow yourself to be diverted all day so that you achieve little at work, you pack you briefcase full of things you should have done that day so you can look at them at home, you arrive home and immediately tell your partner how awful your day has been (no consideration for them or how their day went), sit down, pour over your papers with glazed eyes and get no further with them as your mind drifts off and worries about anything and everything.

In this scenario you have achieved nothing positive, convinced yourself you are a failure, alienated your spouse and probably taken years off your life.

We can all identify times like these – not necessarily whole days at a time written off but certainly an hour here, half a day there. So, what is self management and how can it help us?

First, it is important to recognise that there is no magic. Self management is something we all do, to a greater or lesser extent. But like running, although we can all do it for a while, if we are out of training we cannot do it for very long. If you want to improve your self management therefore you must remind yourself to practice – to do some training.

You need to start by organising yourself, your time, your aspirations, your thoughts and feelings and get them into shape. Your brain is very powerful and has enormous – often unused – capacity and potential. In order to start using it better you need to be aware of yourself, what you like and do not like, what you are good at and what you are not. You need to work from the inside out.

So the first thing to do is to take stock of yourself. Give yourself a little space and time to think about you. Do this on a regular basis in order to review yourself and to replan. The Temple of Apollo at Delphi contains a short inscription worth keeping in mind at all times which reads, 'KNOW YOURSELF'. Improving your self-awareness requires honesty and openness – there is no point trying to kid yourself. Look at yourself subjectively – how do I see myself ?– and objectively – how do others see me?

Try to start treating yourself like a good friend – do not worry that it sounds like the beginning of schizophrenia, it is more likely to stop you going mad than start you off. (If you are going to talk to yourself out loud though you had better wait till you are alone or others will think you are going crazy!)

Get to know yourself. Ask yourself 'Who am I

Chapter Seven

Managing Yourself and Your Team

7.1 Self Management

As a child, a student and an employee there has usually been someone to tell you what to do – at least part of the time. Certainly there has been someone to guide you, to help you set priorities and to have an overview on your life, your job and your development.

As you progress in business you will have fewer and fewer people to turn to for help and advice, and will find more and more people turning to you instead. You will therefore need to learn to manage yourself if you are not to drift or be driven by outside forces.

How many times have you intended to do something and been side-tracked by a colleague? How often have you reached the end of the day without apparently achieving anything? The result is of course a sense of frustration, of being out of control and of failure. This can lead to stress and can affect your whole life and your health very badly. Stress is more likely to be caused by what you do not do than by doing too much.

Business today lays a big emphasis on effectiveness, performance and using potential. If these are to be achieved for the company as a whole, you will have to start with individuals, work out to colleagues and then on to clients and suppliers. Most of all you will have to start with yourself.

Self management will help you achieve a new found freedom and energy. Instead of a feeling of drifting and being blown by the wind, you will enjoy a sense of direction, of being on course and being in control of your own life. It will affect not only your business life but your home and social life too.

The more responsibility you have in business the more it is possible to enjoy it and feel you are in control. However, as you become more involved in your work there is a great temptation to let it take over altogether. Working hard is fine, working efficiently is better. Working long hours may be necessary but it may also be self-indulgent.

Summary and Checklist

6.1 Communications and Structure

At 15-25 employees, informal communications and structure begin to be replaced by formal systems.

Growth offers the opportunity for individuals to fulfil their ambitions. Sudden absence of growth can lead to the exodus of middle management.

6.2 Specialisation in Design

Separation of teams by design discipline can lead to rivalry. A possible solution is to mix disciplines in the same environment.

Fee splits and responsibility definitions on projects between disciplines requires flexible thinking to avoid problems.

6.3 Specialisation in Marketing

Marketing-sector independence concentrates effort and expertise but requires greater cooperation and communication to avoid mistakes and rivalry.

6.4 Divisionalisation

All problems are amplified. Profit-centre mentality causes logistical and emotional upsets.

6.5 Losing the Spice of Life

The individual designer rising to the top of a large company will tend to specialise more and more At the top, the designer's role will be design direction and management of others. If you want to go on designing, stay small.

6.5 Losing the Spice of Life

One last problem arising from growth and specialisation is peculiar to design businesses. Most designers want to undertake a variety of work, although not every designer is able to cope with the full spectrum even within his own discipline. However, the better the designer the greater the range of work he is likely to be able to do and want to do.

Unfortunately for the good designers, their path towards the top of the company often leads them to greater specialisation rather than greater range. The larger the company, the greater the degree of specialisation and frequently the greater the feeling of frustration.

The satisfaction for designers who rise to the top of a company has to come from design direction and from management rather than hands-on design. Not every designer, however talented, can make that adjustment. If you want to go on designing for the rest of your life, keep your company small. If you believe you will enjoy the challenge of learning a new discipline that of becoming a good manager of others then push ahead with your plans for growth.

There is room in the design industry for large and small business. You should enjoy your business so run the business you want – do not let the business run you.

all it is a project that has a fee income based on full rates? This of course is not acceptable to the division whose project it is. This division is carrying overhead costs (premises, administration, marketing) which make up part of the hourly rate calculation. These are not being covered if the full rate is paid to another division, nor is there any profit in this part of the project.

This situation has been known to cause such frustration that one division in a large company has paid a designer from another division direct as a freelance payment to work in the evening or at weekends in order to resolve it. This perhaps is the most ludicrous of all solutions, as the company is then paying this designer to sit doing nothing during the day and then paying him again to come and work for the company is his spare time.

Ludicrous it may be, but you can see how the situation can easily arise – and there is no simple solution to the problem once you reach the size that you feel you must have divisions based on profit centres.

6.4 Divisionalisation

All of the problems of specialisation in both design and marketing are amplified with the creation of divisions. Many of the very large design businesses have established divisions or even separate individual companies within an overall group. It makes little difference which route is taken – divisions or companies – the effect is the same.

The main change in this approach compared to structures described previously is the move from income centres or sectors to profit centres. A group of people only become a profit centre when both income and costs are isolated within a self-contained group. In other words they act like independent companies with their own clients, their own projects, their own designers and their own marketing staff.

There is a temptation to accept that this is the only way a large design business can be structured, and maybe that is so. However, the effect of that structure can be positive or negative depending upon the overview and flexibility of mind of those running the business.

At one end of the scale the individual divisions are run totally independently sharing only their origins or ownership. In terms of general business strategy there is nothing wrong in that at all. In a design business, however, it does seem like a terrible waste of opportunity.

Design is a business where broad experience is helpful, stimulation is essential and lateral thinking is integral. To partition one set of designers from another and one set of clients from another by your attitude to divisions seems absolute folly. If your business grows to a size where divisions are the inevitable consequence, make every effort to open lines of communication between them.

A divisionalised design business run by pure logic and profit motivation will throw up some extraordinary anomalies. For example, one division has a project and would like to use the talent and experience of a designer in another division which happens to be going through a trough period. There should be no problem – surely it is in the interest of the whole company that this should happen.

Bringing profit-based logic into the picture, however, causes a real headache. What arrangement should be made for paying for the input of the designer from the other division? Two obvious choices are to pay salary plus overhead costs or to pay the full charge out rate.

Looking at each in turn highlights the problem you are faced with. If the remuneration to the division employing the designer simply covers his cost then as soon as a new project is won by that division they will want to put him on that new project. When he had nothing else to do they would rather he was earning something rather than nothing, but when the work is there for him to earn full profit it is no longer acceptable.

So why not charge full rates for his time – after

6.3 Specialisation in Marketing

On the marketing side, you have probably started to divide your business into sectors in order to target your approaches to potential clients and to make the most efficient use of your marketing team. This allows marketing sector managers to concentrate on one area and build up their knowledge and expertise in that field.

Again, the development of a specialised structure can cause problems. Having established a certain independence for individual marketing managers, you will have to resolve your efforts to ensure co-operation. Communication between marketing sector managers is vital in order to maximise the use of new business leads and market-intelligence data that they are all generating.

Also, they must know about each other's approaches to potential clients. There is nothing worse than two people following up one lead without being aware of each other's activities. The potential client who has been approached will be immediately and thoroughly convinced that you could not handle a project for him as you cannot even organise your business and will look elsewhere.

Another thing to be careful of with your sector marketing managers is setting targets for each of them and using the achievement of these targets as the measure for success. If the sector targets themselves become more important than the overall company targets then you will find this leads to the jealous guarding of potential clients and a general lack of co-operation.

6.2 Specialisation in Design

If your design business employs designers from more than one discipline, such as graphics and interiors, they will to a large extent work separately and report to different managers. As your business grows the groups of designers under each discipline will grow and necessarily be distanced from each other physically. This can lead to rivalry.

For example, if a project involves both groups – graphics and interiors – then the agreed fees will have to be divided between the two groups. So long as the scope of work anticipated for each group is understood then this division of the fees should be relatively straight forward. Suppose, however, that during the project it transpires that the best approach requires a rather different split in the workload.

Unless you are reasonably flexible in your thinking you may find that you have created a real obstruction to handling the project in the best possible manner. However, this should not become a major issue at this level of growth – i.e. a level at which design discipline is the only basis for the division of the organisation.

like that and what you will need are new skills. You have to progress from direct, hands-on management to the more indirect style of recruitment and training, of systems and written rules, and if that does not appeal to you, think carefully about growth, whether you want it and why.

If you are not put off by the prospect of growth, then prepare for the other differences between small and large design businesses. Growth leads inevitably to the need for specialists within the organisation – in particular design specialists and marketing specialists.

Chapter Six

Larger Companies

6.1 Communication and Structure

As your business grows you will find you are faced with many of the same problems – only larger – and also some new ones. Informal communications, which are possible in a small company, are very effective. Everyone knows what is happening and how things should be done because you are all together, constantly rubbing shoulders with one another and able to catch something before it goes wrong.

A significant change tends to take place at around 15 to 25 employees, depending upon the nature of the premises occupied. You can no longer rely on a comment in passing to keep things on the straight and narrow. More formality is required whether it is liked or not.

This means the introduction of formal responsibilities and structures, memos and forms, systems for communicating information. The knock-on effect of all that is often for groups within groups to spring up and for vested interest and protective thinking to take over the motivation of individuals.

Growth in itself is not a bad thing – far from it. It gives you the chance to employ good quality senior staff, to promote good existing staff, to delegate thoroughly and effectively. Everyone's ambitions can be fulfilled.

Growth causes communication problems and structural problems, but is enjoyed by all who are ambitious so long as it continues. For there is another problem which arises if the growth stops – there is nowhere for the recently fuelled ambitions of your top employees to develop any more and that can cause an exodus of the worst kind.

Having built up your business and delegated the management of it to up and coming middle managers, they decided to go off to new pastures and leave you feeling as if you are driving a runaway car with no steering wheel and no brakes.

That is of course a very simplistic, black-and-white picture of events and you would be extremely unlucky to experience it in those terms. However, there will no doubt be times when it feels exactly

Handle PR and confidentiality carefully. Do not break confidentiality but do not miss out on PR either.

Balance integrity and arrogance. Be sure you are right before standing your ground.

Set up internal checking systems to avoid mistakes – involve more than one person in checking. Even better, involve your client.

If you staff leave, are ill, or act in a way that might adversely affect you work, move in on the situation quickly and positively.

Use cashflow forecasts and debtors reports to give and indication of the likely future cash position.

Compare marketing sectors' performance with original targets – if there is a shortfall, increase marketing activity but at the same time reduce the general level of company expenditure if possible. Remember, any reduction in income will lead to a disproportionate reduction in profit because your overheads are relatively fixed.

Use monthly management accounts to review the level of expenditure. Watch for inconsistencies.

5.6 Critical Management Information

Keep three areas in your mind:
Cashflow
New business
Expenditure

5.3 Suppliers

Open accounts and obtain credit wherever possible.

Use order pads. Give clear and accurate descriptions including quantity and price agreed. Check deliveries and raise any queries immediately.

You may wish to limit authorisation of orders, particularly over a certain level of expenditure.

Handling charges are normally added at 17.65 per cent of the net costs.

Beware the temptation to buy large items for your client on order to earn handling-charge income. Suppose the client does not pay – can you afford to take this risk?

Negotiate with suppliers but balance costs savings with quality and service. Review suppliers at regular intervals.

5.4 Employing Staff

Give yourself time to find the right staff.

Advertise or use recruitment agencies.

Use interviews effectively. Select best candidates for second interviews and involve a colleague at this stage. Make candidates sell to you before you sell to them. Do not make it too easy for them; let them do the talking and you listen.

For permanent staff, have standard terms and conditions of employment – normal working hours, overtime, salary reviews, pension, holidays, dismissal, rights to notice, sick pay, health and safety at work, company car, confidentiality, conflict of interest, and freelance work.

Review staff every three months – discuss progress and development.

5.5 The Unforeseen and the Unfortunate

Use insurance selectively. Go direct to insurance company or use broker. Document insurance and professional indemnity insurance can carry very high premiums.

Litigation can be expensive and uses up a great deal of management time. If you have no alternative then do it properly and thoroughly – be prepared to fight all the way.

With slow payers chase hard and let them know you are efficient. Deal with queries on invoices immediately. Consider whether you want to use a factoring company.

Summary and Checklist

5.1 Financial Planning and Budgets

Put down a trading plan for the initial period of trading – probably one year – using the following components:

Anticipated income
Designers' salaries
Marketing costs
Administration and other costs
Premises costs
Interest

Anticipated income – work from order book and chargeable time calculation.

Designers' salaries – at about 3.5 to 1 relationship to net chargeable time.

Marketing costs – including salaries, printed matter, advertising, photography, travel and subsistence. Normally keep to around 10–15 per cent of total income.

Administration and other costs – secretarial staff, receptionist, book keeping, stationery, postage, general travel and subsistence.

Premises costs – rent, rates, services, repairs, electricity, gas, telephone, and insurance.

Interest – payable on loans, overdrafts, lease purchase, etc.

5.2 Project Control and Systems

Keep accurate and complete records of all time spent on projects and all costs incurred.

Record information on a job-number system and feed back regularly (each week if possible) the time and costs on each job to the project leaders and directors.

Two systems:

Timesheets give an overview on each designer each week, but no room for recording materials used, etc.

Jobsheets give designers cumulative information on their part of the job, and room to record materials, but no overview on designer's week

Both require collation of information to give complete picture.

Job numbers should be used for all general ordering – from taxis to typesetting.

Do internal budgets for projects. These may or may not be the same as the fees paid by the client.

'Project update' sheets should be produced and distributed weekly.

basis through the monthly management accounts mentioned earlier. The breakdown of each of the areas – marketing, administration, premises – along with designers' salaries, should all be shown as actual expenditure figures and, alongside, the original budget figures.

Do not be satisfied too easily in this area for the figures can be deceiving. Firstly, it may not be enough to hold to the original budget. If the level of fee income is falling below the original target then all the budgets should be reviewed. A better indicator might be the percentage of net revenue that each area of expenditure represents. This way, if income falls the percentage of net revenue that, say, administration costs represent will rise – thus ringing alarm bells.

Also, even when all the relationships appear to be in balance, the management accounts will still only be a summary. It is possible that one set of costs are on budget because one item is overspent whereas another is underspent. So you should dig a bit deeper from time to time to check it out.

Watch out too for inconsistencies from month to month. It only takes one large item of expenditure to crop up in a different month to the budget plan and the figures will look very different.

is on each response. An example of an overdue debtors' list is given below.

The second area to be monitored is the new business activity and anticipated level of new business gains over the coming months. If your marketing is focused by sector then build up your information this way too. You will have have set targets for the year, again by sector, and can therefore compare actual performance against original expectations.

Be prudent. Do not convince yourself that a shortfall will be made up unless there is a very sound reason for believing it. At least by knowing that there is likely to be a shortfall in fee income you will have the chance to take some corrective action – namely increase your efforts to win new business and at the same time tighten up on expenditure.

With regard to reviewing expenditure – the third area – this should be possible on a regular

OVERDUE DEBTORS REPORT
AS AT:

CLIENT	OVER 3 MONTHS	3 MONTH	2 MONTH	1 MONTH	TOTAL	PERSON CHASING DEBT	REASON FOR NON-PAYMENT	ACTION SINCE LAST REPORT
ABE LTD	5,250				5,250	CC	QUERY	CHEQUE PROMISED 30/5
CDE LTD			2,500	1,500	4,000	AB	NONE	LETTER SENT 3/5
EDG LTD	250		8,500		8,750	CC	QUERY	LETTER SENT 3/5
GH LTD				2,250	2,250	CC	NONE	CHEQUE PROMISED 30/5
IJ LTD				1,200	1,200	CB	NONE	NONE
TOTAL	5,500	0	11,000	4,950	21,450			
%	25.64%	0.00%	51.28%	23.08%	100.00%			

Figure 10: overdue debtors chart

	JAN	FEB	MAR	APR	MAY	JUN	JUL	AUG	SEP	OCT	NOV	DEC
HOURS + FEES CHARGED	60,000	60,000	65,000	65,000	75,000	75,000	75,000	75,000	80,000	80,000	80,000	80,000
RECHARGED ITEMS	2,500	2,500	2,500	2,500	2,500	2,500	3,000	3,000	3,000	3,000	3,000	3,000
TOTAL INCOME	62,500	62,500	67,500	67,500	77,500	77,500	78,000	78,000	83,000	83,000	83,000	83,000
OUTSIDE SERVICES	1,500	1,500	1,500	1,500	1,500	1,500	1,750	1,750	1,750	1,750	1,750	1,750
MATERIALS	500	500	500	500	500	500	600	600	600	600	600	600
SALARIES	25,000	25,000	27,000	27,000	32,000	32,000	32,000	32,000	35,000	35,000	35,000	35,000
RECRUITMENT			1,500		3,000				1,500			
TRAINING			800			1,200						
PHOTOGRAPHY	500	500	500	500	1,000	500	500	1,000	500	500	1,000	
SALES LITERATURE						2,000					500	
ADVERTISING			2,000			2,000			2,000			
CAR COSTS	700			400					400			
TRAVEL & SUBSISTENCE	500	500	500	500	500	500	500	500	500	500	500	500
RENT	7,500			7,500			7,500			7,500		
RATES	12,000											
REPAIRS	100	100	100	100	100	100	100	100	100	100	100	100
TELEPHONE			750			750			750			750
LIGHT & HEAT		200			200			200			200	
CLEANING	150	150	150	150	150	150	150	150	150	150	150	150
CANTEEN	100	100	100	100	100	100	100	100	100	100	100	100
INSURANCE	1,000											
POSTAGE	120	120	120	120	120	120	120	120	120	120	120	120
EQUIPMENT		2,000			4,500				8,000			
SUNDRIES	150	150	150	150	150	150	150	150	150	150	150	150
LOAN INTEREST			1,750			2,250			1,750			1,650
CORPORATION TAX						45,000						
VAT - NET			32,000			35,000			38,000			42,000
TOTAL EXPENDITURE	49,820	30,820	69,420	38,520	43,820	123,820	43,470	36,670	91,370	46,470	40,170	82,870
MONTH SURPLUS	12,680	31,680	-1,920	28,980	33,680	-46,320	34,530	41,330	-8,370	36,530	42,830	130
BALANCE B/F	-55,400	-42,720	-11,040	-12,960	16,020	49,700	3,380	37,910	79,240	70,870	107,400	150,230
CUMULATIVE SURPLUS	-42,720	-11,040	-12,960	16,020	49,700	3,380	37,910	79,240	70,870	107,400	150,230	150,360

Figure 8: a cashflow forecast

5.6 Critical Management Information

It is important for the chief executive or managing director of a company to keep three areas of the business uppermost in their mind – cashflow, new business, and expenditure. Whatever their title, someone in the company must take on the role of looking after the performance and financial welfare of the company to ensure that it remains sound and healthy.

Keeping a close watch on these three areas will enable them to do this. Healthy cashflow is essential; if the bills cannot be paid a company can be wound up even if it is otherwise sound. A shortfall in new business activity will eventually lead to a slump in fee income and often to a dramatic fall in profit levels. Less dramatically, but equally dangerously, a lack of control over expenditure can lead to a reduction in profitability that is more insidious, sometimes hard to recognise, and usually quite difficult and painful to reverse.

A cashflow forecast is something you will have to do when starting a business because you need to determine the extent of your borrowing requirement. The need to forecast cashflow does not stop there, however. In fact it never stops, unless you are awash with cash, in which case you are almost certainly not making the most of your resources.

It is a complex exercise though, and therefore there is a great temptation to ignore it unless you feel things might be getting desperate and then quickly put a cashflow forecast together to check out your suspicions.

This management by the seat of the pants may see you through so long as you are not too ambitious. Slow, steady growth in a reasonably healthy business does not require the same control as a rapidly expanding business.

However often you feel you need to produce a forecast of cashflow, the example in figure 9 should at least give you the main items to include. Remember, this forecast is based literally on the movement of cash into and out of your bank account, not on how much work was done that month or how much was invoiced, or any other indicators of that kind.

There is another indicator for the chief executive to watch with regard to the cash situation, and that is the level of debtors – and, more specifically, the overdue debtors.

If the overall level of debtors is increasing it may simply be an indication that the overall level of business has increased. But if the level of debtors is increasing out of proportion to fee income then this is a much more worrying trend and requires some urgent action.

At this point you need to know how the debtors break down. Highlight those whose debt exceeds your normal terms of business – say, more than one month. These debts are overdue and should be chased hard. Even better, analyse each one by how long it is overdue and by what the situation

you make the mistake you will still have to take at least part of the blame. Whether 'blame' becomes 'cost' depends on individual circumstances and very largely on how reasonable your client is.

Finally, in the area of the unforeseen, there are the problems that staff can create. A key member of your team leaving in the middle of a project, sudden illness, and marital problems are examples of the unforeseeable that can upset the smooth running of your company. Equally upsetting is the appearance of a prima dona or a moaner – someone you have just employed and had high hopes for who turns out to be a square peg in a round hole.

There is no easy answer to this kind of problem, but more often than not the important thing to do is to act. Be compassionate, be firm, be whatever is appropriate, but act and act quickly. Projects can drift off course very easily, companies too can lose their momentum if they are left to fate. Sometimes you will be faced with unpleasant decisions, but waiting usually only makes them worse.

significant percentage for themselves in order to cover their time and risk. This usually falls in the region of 1–2.5 percent of your turnover. You would have to decide how much the service is worth to you compared to chasing the debts yourself.

Usually the factoring service also includes undertaking legal action if required. Here you will gain from the experience the factoring company has in this field, but you will still be involved in the proceedings in the normal, time-consuming way.

Confidentiality can occasionally be a problem when working on a brand-new concept for a client. It is better to err on the side of caution here, because a journalist will generally publish and be damned, if it is a good story – after all, he wants to publish before his competitors do.

Be careful what you say to journalists even when you know and trust them. Be prepared before you talk to them – know what you can and cannot say. If in doubt check with the client – they will normally be reasonable. Sometimes a client will withhold permission for PR in a way that you believe to be unreasonable and beyond any agreement on confidentiality. At this point you have a difficult decision to make as to whether to go ahead with your PR or not.

The principle surely must be that of integrity. As long as you are not breaking confidences or releasing information that could harm your client's business, it would seem reasonable to ahead, but with extreme care.

Confidentiality is certainly not the only area in which a client can be difficult. There are times when a client simply will not take your advice and insists on a different approach. At this point you must do some soul searching.

Is your advice right? Is your design solution right on brief? Is your client in a position to make a better decision than you?

Be careful of being arrogant and high handed – you may regret it and certainly it will not help you to reach agreement. However, there are times when you are convinced that your advice is right, and believe that your integrity as a consultant is at stake. At this point you may have to part company with your client in order to retain your integrity, or else be prepared to be pushed around by this client and used simply as a drawing or artwork service.

There is a difference between a tough client and an awkward client. However, neither type will show you any sympathy if you make a mistake. Simple mistakes do occur, but with careful checking they need never see the light of day. Set up internal checking systems, involve more than one person in the checking of drawing or artwork and, even better, involve the client.

Once you have checked everything yourself, show the work to your client and have him check and sign it. At least this way he may have some sympathy if a mistake still gets through. Do not believe that by involving the client in the checking procedure, however, that you are absolved – if

possibilities. A number of design businesses and architectural practices for example, have undertaken work for which the client refuses to pay. In these circumstances, the design business may have to become the plaintiff in litigation – in other words, sue his client – in order to even have a chance of being paid. Some professional indemnity policies cover this, with others it is an optional extra.

At this point you would have to weigh up the consequences of pursuing it in this way. For relatively small sums (currently under £5000 inclusive of VAT, court fees, interest, etc), you can pursue it through the County Court at very little cost. For larger sums you can use a solicitor to write a strongly worded letter to your client and in many cases this has the desired effect.

However, should you have to launch major legal action against a client the costs are likely to move from a few hundred pounds to several thousand pounds – even if they eventually settle out of court. Of course if you do win your case, some, if not all, of your legal costs will be met by your client – but this can take up to two years, possibly longer.

The best advice is to decide early on whether you are going to pursue it or not – then either cut your losses or fight all the way. It is important to realise in advance, however, that if you are going to fight and win it will take an enormous amount of management time and should not be entered into lightly.

One way to stop the situation becoming too dire is to keep very tight control of your debtors (clients who owe you money). Chasing debts is a tedious and frustrating pastime, but essential.

Some clients – and often these are the very large organisations – are slow payers. Ingenious excuses are invented to explain delays in payment by one clerk after another as you are passed around the country from office to office and back again.

One of the favourite delaying devices is to raise a query on the invoice. Even better, they wait until your invoice is already a month overdue before they raise a query! Deal with queries quickly and efficiently. Involve everybody in your company if you have to, but answer it quickly. Otherwise it takes the lowest priority on your list of things to do, and three months later the invoice will still be unpaid. Not only have you played havoc with your cashflow, you have also indicated to your client that you are not bothered about when they pay you – so compounding the problem next time.

If you do not want to, or do not feel capable of handling your own debt collection you can come to an agreement with another company which is called 'factoring'. In simple terms the other company pays the amount due to you from your invoices and then undertakes to recover the money from your clients. While this sounds ideal, the catch is that the factors chase your clients direct for the monies due and also keep a

5.5 The Unforeseen and the Unfortunate

Nuclear war and 'acts of God' apart, there are occasions when you either wished you had taken out insurance, or, where you do have insurance, you wished it covered the event that had just occurred and caused havoc.

On the other hand the insurance policy that covered every eventuality would carry such a large premium that you would be put out of business by paying it.

As with most business decisions, taking up insurance is a choice between risk, likelihood and cost. Most decisions regarding insurance are therefore individual, personal decisions. However you should carry insurance to cover your liability towards your staff should anything happen to them during the time they are in your premises.

All large insurance companies will be able to offer the general insurance cover – car insurance (if you have any company cars), building insurance (if required – your landlord may for example cover this and then pass the charge, or part of it, to you), contents insurance (furniture, equipment, materials that could be stolen or damaged) and all risks cover (for items that you or your staff might carry with them outside your working premises. As an alternative to going direct to an insurance company, you could use a broker who can select the best policy for each type of cover and can shop around the different insurance companies for the best deal.

In both cases – the insurance company or the broker – you are likely to find you are pressed to consider other insurance 'opportunities' such as life assurance for you and your staff, income protection plans, pension plans, and so on. These may be an excellent idea but do not be persuaded to take on too much too soon or anything you do not really need – you should keep your cash resources for your main business first.

Apart from the usual insurances there are two others you might consider. First, you can take out insurance to cover loss of documents, drawings, artwork and so on. However, if you value these at the time taken to re-create all of them at your normal hourly rates your premium will be very high. You could take up cover to allow for the cost of reproducing a limited number of items instead and find this affordable.

Secondly, there is a professional indemnity insurance which covers you for negligence, error or omission in the professional conduct of your business. Architects and engineers tend to carry professional indemnity insurance and their premiums are often many thousands of pounds. Design businesses tend to be seen in much the same light despite the real risks usually being a great deal smaller. Litigation does seem to be on the increase, however, and this type of insurance may be something you wish to consider.

Not all litigation would automatically fall into the areas covered by professional indemnity insurance and you should be aware of other

holidays, dismissal, rights to notice, sick pay, health and safety at work, company car (if applicable), confidentiality, conflict of interest and freelance work.

It is a good idea to have the period of the first three months as a trial period and it is in any case good management practice to have regular reviews with all staff every three months (or at least every six months) to discuss their progress. It is an opportunity for both sides to talk freely about the individual's development and future potential.

You may from time to time have more work than your permanent staff can handle and cannot recruit new designers in time to cope with this workload. At this point freelance help can be very useful. In fact, some design business run almost all the time with some freelance staff to allow for peaks and troughs.

Freelance staff undertaking work in the name of your company may not feel bound by the same sense of duty and allegiance as your full time staff. Be careful about confidential projects they might see or be working on and be sure the content of their work is thoroughly checked as you will still be liable for any potential professional negligence. If you do carry professional indemnity insurance against such risks, however, you should normally find that freelance staff are covered by this as well as full-time designers.

If the freelance designers are working at your premises you could be held liable by the Inland Revenue for any unpaid tax or national insurance contributions. This risk can be avoided if you pay through a bona fide agency, or if you deduct tax through the PAYE system or if you get them to sign a declaration of self-employment.

5.4 Employing Staff

Having decided on your approach to the business you will have set yourself some guidelines as to whether you will recruit juniors to work under your instruction or 'thinkers' to develop design concepts themselves under your overall guidance.

It is particularly important if you are employing thinkers that you take your time and give yourself every chance to find the right designers for your company.

Once you have decided what level of experience you are looking for to achieve the right balance in the company as a whole, you will need either to advertise or employ a recruitment agency. Advertising can be cheaper but only if you succeed first time. Also you have to sift through the responses yourself.

On the other hand, recruitment agencies usually charge 15 to 18 per cent of a year's salary for their service – payable only if you employ someone from the exercise.

You will probably find it relatively easy to find someone, but harder to find the one you want – and even more difficult to fit this one to the salary you had identified! It is for these reasons that the interview stage of the process is particularly important. When employing designers at least there is a portfolio of work to look at – probably enough to decide on whether to shortlist the candidate.

Usually it helps to have someone back for a second interview and to involve a second member of your company in the process at that time. The most important thing in an interview is to find out about the candidate first – leave the selling of your company to him until you are convinced you probably would like him to join. Apart from avoiding wasting your time this way it also means you will get a true picture from him rather than a repetition of your own thoughts and values. Listen rather than talk and you will have more to remember about him after the interview is over.

Do not be afraid to put the candidate on the spot to see how he comes through. Ask why he did something in the way he did on the projects he presents – making sure he understood and can explain coherently the benefits of the approach. Ask him what he knows about your company – see whether he has bothered to do any homework before coming to the interview. Ask him what projects he admires that other people have done – see whether he keeps his eyes open and what he is attracted to.

All of this will give you more clues to his personality and at the same time make him feel he has had to work hard to get the job – thus adding perceived value to the achievement of being selected.

With permanent staff you should have standard terms and conditions of employment which each new employee should read and sign. The subjects these should cover include normal working hours, overtime, salary reviews, pension (if applicable),

insurance policies which specifically exclude contract work of this kind.

With regard to your regular suppliers – stationery, materials, messenger deliveries, and so on – use your best negotiating skills and check out a number of suppliers to ensure you are getting the best deal. However, remember that financial considerations are not everything – quality and service are important to you in your business, sometimes more than discounts.

Finally, review your regular suppliers from time to time. You do not have to change just for the sake of it but it rarely does any harm to let them know they are under review. Having said that, the best agreements are ones that both sides are pleased with – so negotiate hard but fairly and treat your chosen supplier with due consideration in order to get the best out of him.

5.3 Suppliers

When you start a business you may find it hard to obtain credit from suppliers until you have built up a track record and some assets on your balance sheet. However, you should work hard to build up credibility with your suppliers, opening accounts with them where possible. This has two major benefits. First of all the administration is much simpler if you can pay one invoice per month rather than paying cash every time you order something. Secondly, without credit you will be covering the cost of the items for probably two months – by the time you have invoiced your client and he has paid your invoice.

Make sure your paperwork is clear and accurate. You should have order pads with two or three duplicate copies for internal use. Apart from identifying the job number or reference when you complete the order form, you should always clearly indicate the quantity of items ordered, the price agreed and the delivery date or time it is required by. When items are delivered check them carefully and raise any queries straight away – do not forget to follow up any problems and better still, commit the problem to paper in a confirmation letter.

It may be a wise precaution to limit the number of people authorised to sign orders – particularly those for goods over a certain level of expenditure. When buying in outside services on behalf of your client – such as photography or litho printing – it is normal practice to add a handling charge before invoicing the client. This charge is often set at 17.65 per cent of the net costs which produces a figure of 15 per cent of the gross charge to the client as follows:

OUTSIDE SERVICE	850
HANDLING CHARGE	150
GROSS CHARGE TO CLIENT	£1,000

The handling charge of £150 is 17.65 per cent of £850 and 15 per cent of £1,000.

You may be tempted to buy as many outside services as possible for your clients – but beware the risks. By purchasing on behalf of your client it will normally be taken by the supplier that you are acting as a 'principal' in the matter. In other words, you will be responsible for paying the supplier whether or not your client pays you. Make sure, therefore, that you can afford to take this risk.

In addition, your client will expect more of you and may try to hold you jointly responsible with the supplier for any mistakes or delays.

With interior design or architectural practices the opportunities and the risks are multiplied many times if you were to consider acting as principal on payments to the building contractor or furniture supplier. It is extremely rare that it is ever worth taking on this level of risk and this is reflected in many professional indemnity

you want to use this information. On most projects it is good to give the individual designers a budgeted number of hours to work to. This can be identified on the jobsheet if applicable or just given to the designer before starting work.

Even where the precise number of hours is not given to the individual designer, at least the project leader must have a budget for the project as a whole. This budget may or may not be the same as the agreed fees. Sometimes you may decide to invest more time than the fees will cover at your normal hourly rates, sometimes it is the other way around.

If possible, set up a system whereby a summary of all active projects (project update sheet) is produced on a weekly basis and circulated to all project leaders. This work in progress summary should list the projects, show the budget set for the project (or stage of the project) and cumulative hours worked to date – below is an example of a project update sheet.

You can make your format as simple or complex as you like, so long as it tells you the vital information – i.e. whether you are likely to exceed budget. If you are working to a fixed fee this will give you the chance to control your hours before it is too late. If you have a more flexible arrangement with your client, it will at least allow you to warn him that the budget is likely to be exceeded.

CLIENT	PROJECT	DESIGNER IN CHARGE	BUDGET £	HOURS TO DATE x £
AB Ltd	Brochure	D L	2,500	1,750
CD Ltd	Packaging	O M	2,000	2,150
EF Ltd	Retail Concept	B J	13,000	10,540

to buy – although the programmes may be. However, it is normally best not to rush into any decisions regarding computerised systems or accounting software – wait until you have developed a manual system that works for you.

The key to all project control is a job number system against which all information is recorded – man hours and expenses. The recording of hours worked on a project can be done using one of two alternative formats – timesheets or jobsheets.

The timesheet is a method of recording hours by designer each week. The advantage is that it gives you an overview on the designer's time – in other words you can cope with manually.

The jobsheet is used to record information (including, but not exclusively, hours worked) on a job by job basis and runs over a number of weeks. This allows the designer to see his hours accumulating on a project against a budget and also to record materials used, outside services ordered and so on. Because graphic designers tend to use more materials, the jobsheet system is particularly useful for them.

Examples of both systems are shown in figures 6 and 7. Either system will work as long as the designer fills them in properly. There is also no reason why both systems cannot be integrated within one company – for example jobsheets for graphic designers and timesheets for interior designers.

Both systems require collection of information in order to give the project leader the overall picture. With the jobsheet, as soon as a project has more than one designer working on it, you will have to gather the information from each jobsheet to give the total picture. With the timesheet, not only will various designers' hours have to be collected but also the accumulation week by week.

There is one other major difference between the two systems and that is regarding the weekly collection of information. If you want to know each week the hours per project and the hours per designer, you will have to collect that information from the designers' sheets. The weekly timesheet can just be handed in, but the jobsheets will have to be collected, weekly records updated and jobsheets handed back to the designer in order to accomplish the same result.

The job number system has other uses beyond recording time and materials of course. Every time something is ordered or spent against a job – be it typesetting or a taxi – the job must be identified by its number so that all these items can be brought together before invoicing the client.

If the designers are disciplined and use the system correctly, then all should be well. However, in reality they will almost certainly need 'encouragement' to remember to log expenditure against a project or even to fill in their timesheet or jobsheet on time.

Once you have set up a system for recording project information you must then decide how

charge cards. Each time you purchase something from a store it is recorded and, in order for you to know how much has been spent in each store, regular statements are issued.

Imagine that every project is like a store, then set up a charging system so that every time you purchase in a store (i.e. spend time on a project or order something for it) it is recorded. Then you simply set up a feedback system – ideally weekly – to show a summary of the activity during the period.

The stores have powerful computers recording information and generating statements in order to handle the enormous number of transactions. Even in a design business the volume of information can be frightening. You will therefore have to decide whether to invest in a complex computerised system or instead to reduce the volume of analysis from information generated down to the level of priority you can cope with manually.

These days computers are not very expensive

Figure 7: a timesheet

5.2 Project Control and Systems

Income from projects is the lifeblood of a design business and it is essential that you keep accurate records of all time spent and all costs incurred. Furthermore, up-to-date information regarding the state of play on each project must be fed back to the project leaders and directors so that they can see whether projects are running to budget.

It is no different to having a number of shopping

Figure 6: a jobsheet

PROMOTIONAL EXPENDITURE

Sales literature	0	250	1,600	1,500	3,000
Advertising	0	250	3,600	1,500	3,000
Public relations	500	500	3,000	3,000	6,000
Photography	900	500	3,800	3,000	6,000
TOTAL PROMOTION	1,400	1,500	1,200	9,000	18,000

OVERHEADS

Rent	3,000	3,000	18,000	18,000	36,000
Rates	250	250	1,500	1,500	3,000
Service charge	200	200	1,200	1,200	2,400
Heat and light	210	200	1,420	1,200	2,400
Equipment depreciation	310	300	1,860	1,800	3,600
Insurance	0	0	260	260	520
TOTAL OVERHEAD	3,970	3,950	24,240	23,960	47,920

OVERHEADS SPLIT BY DEPARTMENT

GRAPHICS (30%)	1,191	1,185	7,272	7,188	14,376
INTERIORS (35%)	1,390	1,383	8,484	8,386	16,772
MARKETING (15%)	596	593	3,636	3,594	7,188
ADMINISTRATION (20%)	794	790	4,848	4,792	9,584
TOTAL OVERHEAD	3,970	3,950	24,240	23,960	47,920

INTERIORS STUDIO

Fee revenue	17,300	16,000	97,400	96,000	192,000
less write-offs	1,100	1,200	6,800	7,200	14,400
plus mark-ups	900	1,000	5,800	6,000	12,000
NET REVENUE	17,100	15,800	96,400	94,800	189,600
Salaries	7,900	7,700	46,400	46,000	92,000
Cars	700	700	4,200	4,200	8,400
Uncharged materials	60	50	320	300	600
Travel & subsistence	50	50	290	300	600
Overheads	1,390	1,383	8,484	8,386	16,772
TOTAL COSTS	10,100	9,883	59,694	59,186	118,372
NET CONTRIBUTION	7,001	5,918	36,706	35,614	71,228

MARKETING

FEES EARNED	1,500	1,800	8,600	10,800	21,600
Salaries	2,000	2,000	12,000	12,000	24,000
Cars	700	700	4,200	4,200	8,400
Travel & subsistence	160	150	880	900	1,800
Overheads	596	593	3,636	3,594	7,188
TOTAL COSTS	3,456	3,443	20,716	20,694	41,388
NET COSTS	1,956	1,643	12,116	9,894	19,788

ADMINISTRATION

Salaries	1,500	1,500	9,000	9,000	18,000
Cars	0	0	0	0	0
Overheads	794	790	4,848	4,792	9,584
Canteen	80	70	450	420	840
Cleaning	70	70	440	420	840
Postage	110	100	720	600	1,200
Stationery	50	400	2,500	2,400	4,800
Professional fees	0	0	1,500	1,600	3,200
Sundry	120	100	540	600	1,200
TOTAL COSTS	2,724	3,030	19,998	19,832	39,664

MANAGEMENT ACCOUNTS
YEAR - JAN TO DEC 1992

MONTH - JUNE 1992	MONTH ACTUAL	MONTH BUDGET	CUMULATIVE ACTUAL	CUMULATIVE BUDGET	TOTAL YEAR BUDGET
SUMMARY					
GRAPHICS NET REVENUE	14,480	14,000	86,600	83,000	166,000
GRAPHICS COSTS	9,701	9,535	56,852	56,088	112,176
GRAPHICS CONTRIBUTION	4,779	4,465	29,748	26,912	53,824
INTERIORS NET REVENUE	17,100	15,800	96,400	94,800	189,600
INTERIORS COSTS	10,275	9,883	59,694	59,186	118,372
INTERIORS CONTRIBUTION	6,826	5,918	36,706	35,614	71,228
TOTAL NET REVENUE	31,580	29,800	183,000	177,800	355,600
TOTAL STUDIO CONTRIBUTION	11,605	10,383	66,454	62,526	125,052
NET MARKETING COST	2,031	1,643	12,116	9,894	19,788
PROMOTION	1,400	1,500	12,000	9,000	18,000
ADMINISTRATION	2,824	3,030	19,998	19,832	39,664
TOTAL MARKETING AND ADMINISTRATION	6,255	6,173	44,114	38,726	77,452
NET PROFIT	5,350	4,210	22,340	23,800	47,600
% OF NET REVENUE	16.94%	14.13%	12.21%	13.39%	13.39%
GRAPHICS STUDIO					
Fee revenue	15,200	14,500	86,500	85,000	170,000
less write-offs	1,200	1,000	32,000	5,000	10,000
plus mark-ups	480	500	3,300	3,000	6,000
NET REVENUE	14,480	14,000	86,600	83,000	166,000
Salaries	7,200	7,200	42,500	42,000	84,000
Cars	700	700	4,200	4,200	8,400
Uncharged materials	420	400	2,600	2,400	4,800
Travel & subsistence	40	50	280	300	600
Overheads	1,191	1,185	7,272	7,188	14,376
TOTAL COSTS	9,551	9,535	56,852	56,088	112,176
NET CONTRIBUTION	4,929	4,465	29,748	26,912	53,824

Figure 5: sample management accounts

FEE INCOME		100,000
DESIGNERS' SALARIES	50,000	
MARKETING	10,000	
ADMINISTRATION	15,000	
PREMISES	15,000	
INTEREST	2,500	92,000
NET PROFIT		£8,000

So you have set yourself a target fee income to achieve and budgets for expenditure broken down by different areas of the business. See how vulnerable the profit is. A shortfall of £10,000 on design fees will probably not be so significant that you could reduce the number of designers by one or make any other savings – leading to a loss of £2,000 instead of a profit of £8,000.

This highlights the need for prudent budgeting, flexible salary agreements if possible and constant monitoring of the financial position of the company. Ideally you should produce a monthly set of figures showing the income and expenditure – these are normally called management accounts.

Management accounts are records of performance for the period covered based upon the work carried out during that period – not the amount invoiced. It is therefore necessary to value the work done in order to produce the accounts. Any work done that is not expected to be chargeable must be deducted to avoid producing an over inflated figure.

Having produced a fee turnover level add any other income such as mark up on bought-in services, thus producing a figure for total income. From this must be deducted all costs for the same period. Again this must relate to the cost incurred not amounts paid out.

Apart from producing figures for income, costs and profit, the management accounts can help larger companies identify relative performance and cost of different departments. Whatever the size of the company, the management accounts can be used to check whether performance is in line with expectations. This is done by breaking down the annual budget into the same periods as the management accounts (i.e. monthly or quarterly) and using the same headings. At the end of each period the actual figures can then easily be compared with budgeted figures.

If you find that you cannot produce them monthly, at least have them prepared on a quarterly basis so that they can still act as an early warning of potential income shortfall or over expenditure.

Here is a sample calculation:

TOTAL HOURS AVAILABLE (52 x 5 x 7.5)	1,950
LESS HOLIDAYS, SICK, ETC.	250 −
	1,700
LESS ADMIN & NON CHARGEABLE	300 −
CHARGEABLE HOURS	1,400
HOURLY RATE (SAY £30)	30 x
	42,000
LESS WRITTEN OFF	4,000 −
NET CHARGEABLE	£38,000

If you do this kind of calculation for each designer it will give you a check for your anticipated income figure and also of the size of design team required to accomplish the work. The allowance for 'written off' time is a judgment of how much time may be lost in three ways – overruns on projects, time spent on pitching or new business not covered by clients, and internal projects (work done for your own business).

In order to complete the task you will have to decide on your hourly charge out rates and these in turn should relate to the next component in your budget – salaries.

Opinions vary on the relationship between salary levels and hourly rates. They vary not only between disciplines such as architecture and design, but also from one design business to another. However, the relationship between the income from a designer's net chargeable time and that designer's salary should probably be around 3.5 to 1. Because you are using net chargeable time as your basis, your attitudes towards writing off time, working overtime and so on will affect the relationship between salary and charge out rate.

The third component is the cost of marketing. This will include marketing salaries, printed matter, advertising, photography, travel and subsistence. Unless you are investing in future growth it would not normally be prudent to spend more than 10-15 percent of your total income on marketing costs in any one year.

Fourthly, look at your administration costs, secretarial staff, receptionist, book-keeping, stationery, postage, general travel and subsistence.

Next, add up your premises costs, including rent and rates, services, repairs, electricity, gas, telephone and insurance.

Finally, allow for the interest payable on loans, overdrafts, lease purchase, etc.

This should give you a simple financial plan or budget for the year, the summary of which might be as follows:

Chapter Five

Managing a Design Business

5.1 Financial Planning and Budgets

Before your rush headlong into your first project you must lay down a plan for your first trading period – normally a year. If you have had to raise finance you will have to produce this anyway for the bank, but even if this is not the case you should still budget your first year's trading – and every year after that.

At this stage it is best to keep the format for budgeting to a fairly basic level in order to grasp the fundamental principles.

The key components of your budget will be:

ANTICIPATED INCOME

DESIGNERS' SALARIES

MARKETING COSTS

ADMINISTRATION AND OTHER COSTS

PREMISES COSTS

INTEREST

Taking each in in turn, the most critical figure to get right is your anticipated income. If you set this too high you may in turn commit to costs that are too high and cannot be easily or quickly reduced. On the other hand, if you are too pessimistic you may not be geared up with sufficient resources to handle the work. This is one of the great 'chicken-and-egg' problems and you will never be sure of getting the balance right.

In the first year it will be particularly difficult because no trading pattern has been established and you have no experience on which to build. To a large extent you will have to rely on your anticipated order book and some inspired guesswork.

However, there is a more scientific way of laying down the income level for the year which will certainly be helpful as a check. This is based on the number of fee earners (normally designers) in the company and the percentage of their time you expect to be able to charge.

Make sure with equity capital that you share the same ambitions as your new shareholders.

Prepare a business plan with the following headings:
1. Summary
2. Background
3. Products/services
4. Management and personnel
5. Markets and marketing
6. Design process
7. Financial information
8. Risks and rewards
9. Timescales

Avoid jargon.

4.7 Value-Added Tax

You are likely to trade above the minimum level required for VAT registration.

Make sure your book-keeping requirements have been taken care of from the outset.

4.8 PAYE, National Insurance and Pensions

PAYE tax and National Insurance must be deducted from each employee's pay.

You do not have to arrange pensions for your employees.

Summary and Checklist

4.1 Partners and Philosophy

Would you be best on your own or with partners? Choose your partners carefully.

Consider a business partner with marketing and/or management skills. Consider designers from the same discipline and from different disciplines.

Look for complementary personalities – not necessarily similar.

4.2 Strengths and Weaknesses

Do a SWOT analysis.

STRENGTHS	WEAKNESSES
OPPORTUNITIES	THREATS

Build on your strengths, attend to your weaknesses, take opportunities and beware of threats.

Pick out three or four priority objectives from this exercise. Identify those responsible for achieving the objectives.

4.3 An order book of potential business

Identify confirmed business and potential (probable and possible) business. Spread the anticipated workload over the next few months as value of man hours to be worked.

4.4 What type of organisation?

Partnership or limited company – both available for designers and architects.

Limited company gives more protection for your privately owned assets.

4.5 Overheads

Income fluctuates while overheads remain relatively constant.

Keep your overheads as low as possible – rent, rates, telephones, refurbishment, company cars, equipment, furniture.

Give yourself some flexibility on payment of salaries if you can – pay part monthly and part when you receive payment of your invoices.

4.6 Finance

Decide between commercial loan – e.g. from bank – and equity capital.

4.8 PAYE, National Insurance and Pensions

From the moment you make your first salary payment you will need to make arrangements for pay as you earn (PAYE) tax to be deducted from each individual's pay.

You should also understand that your company must pay an amount over and above the agreed salary by way of national insurance contributions. These additional amounts are currently a further 10.45 per cent over the basic salary for all employees.

With regard to pensions there is no requirement for a company to arrange pensions for its employees. If you are considering doing so, however, take advice from an expert in such matters as this is a complex and continually changing area to deal with.

4.7 Value-Added Tax

If you set up a partnership or limited company it is extremely unlikely that you would trade at a level which is less than the minimum for VAT registration. This level changes regularly and you should check with an accountant the current situation and how to make VAT returns.

It is worth noting here, however, that the assessment of whether your trading level justifies or requires VAT registration is based on your trading during one quarter and not spread over the period of a year. Do not therefore leave it until the end of a year to check or it could cost you a great deal of money in the form of VAT due which you will not be able to recover.

Before you start trading ensure that your book-keeping requirements have been taken care of, as both Customs and Excise (VAT) and Inland Revenue (PAYE and Corporation Tax) will want to check it all out at some point in time. This tends to be an area of business that designers do not have the capability – so find a good (not necessarily expensive) accountant or book-keeper.

If you are considering raising large sums of equity capital then you would be well advised to speak to one of the big accountancy firms who have the experience and ability to get you the best terms. If you do raise capital through a firm of accountants they will take their fee from the sum raised rather than directly from you own resources.

In all cases where you are approaching an organisation for capital, whether loan or venture, you will need to provide certain basic information. Normally this will take the form of a business plan i.e. a summary of your business, your expertise, your expectations and so on.

The main headings for a business plan are as follows:

1. **Summary** – what the money is for, products/services offered by your business, management experience, financial highlights, benefits to investor.

2. **Background** – history of business, present financing, significant successes and the specific project that the money is required for (if appropriate).

3. **Products/Services** – compared to your competitors, development of new services, profitability by service.

4. **Management and personnel** – key managers, their track records, remuneration policies, organisational chart.

5. **Markets and marketing** – your clients and potential clients by sector, your competitors by sector, marketing activity and objectives.

6. **Design process** – explanation of how projects are undertaken, availability of design staff, quality control.

7. **Financial information** – summary of main figures for three years (revenue, profit before tax, capital expenditure, cashflow) plus an explanation in words.

8. **Risks and rewards** – opportunities and threats for the investor to understand (probably as part of SWOT analysis).

9. **Timescales** – major events, objectives by department or sector.

Remember that the people reading your business plan do not understand the particular business you are in so avoid jargon.

4.6 Finance

Most people find it hard to lay their hands on, say, £25,000 to start a business, so most of you will have to approach somebody else for a loan.

There are a number of ways of doing this, but the main consideration is whether you are willing to let someone else own part of your company. Put simply, there are two forms of money available – loans and equity capital.

A loan, which might be available from one of the high-street clearing banks, will give you the facility to borrow cash, against which you will have to pay an agreed rate of interest. If you are starting a company you will probably be asked to pay a higher rate of interest than would apply to a going concern.

In addition to interest payable it is likely that the lender will want some collateral such as a second mortgage on your private property, and it may often be necessary to put some cash in from your own funds as well.

The alternative is to look for equity capital. Here, the investor takes a percentage shareholding in your company from which he expects some income (in the form of dividends) and capital growth (i.e. an increase in the value of the company and therefore his shareholding).

Venture capital, as this is sometimes called, is available from merchant banks and other institutions such as Investors in Industry (3i) and Pension Funds. The advantage of venture capital is that it can be arranged without assets or other security being in place (as will often be the case with a new company starting up). Such investors may wish to combine equity capital and loan arrangements in some cases.

The important element of venture capital investment to remember is that most investors will be looking for some way to get their money back – an 'exit' – as well as a good return on their investment. This is likely to mean that the investor's interests are best served if your company is placed on the stock market (probably the Unlisted Securities Market (USM) as this can be achieved relatively quickly, so that they can sell their shares at a profit.

There are some institutions which are not in such a hurry to find an exit. These bodies do not rely on releasing capital form investments and can therefore hold shares for much longer. Such institutions include 3i and a number of Pension Funds.

There are other ways of giving an investor an exit than going public. Shares can be sold through a private sale, either to another investor or through a management buyout (buying back the shares yourselves or with the help of your employees).

Whatever the exit arrangements, any investor of venture capital will want to see a return on his money year on year. This means the payment of a dividend at a level acceptable to him. This is something you may not have allowed for or anticipated.

4.5 Overheads

One of the most important lessons to learn about a design business is that for the most part it is INCOME that fluctuates and OVERHEADS that remain relatively constant.

The positive side of this is that once the overheads have been paid for it is possible to make a healthy profit from any additional business you can generate. The down side is that if income falls below the level of expenditure on overheads it is very difficult to get back to a profitable position because it is very hard to reduce the overheads at short notice.

So, when setting up a design business keep your overheads as low as possible and do not commit to increasing them until you have to. The kinds of expenditure that should be controlled this way are premises (rent, rates, telephones, refurbishment), company cars, equipment, furniture, and so on. Even with salaries you should try to keep the commitment to pay on a monthly basis to the lowest possible level – then when cash comes in further payments can be made.

The great advantage of setting up a design business is that you can start with very little. Very small investment in capital is required compared to, say, manufacturing-based companies, and the largest expenditure will generally be on salaries. Keep the salaries low and avoid buying major items on behalf of your clients and you can build your business from a very small base.

There are a number of ways in which a flexible salary arrangement can be introduced to help the cash situation. When starting a business with a few people it is possible to be more flexible than with a larger company. Basic salaries paid monthly can be kept to a minimum with an agreement to pay lump sums to supplement when the business (and subsequently the cash) rolls in.

The supplement might be made in the form of bonuses. These can be paid at any time. Tax is payable on bonuses in the same way as on a monthly salary, although the government has introduced a scheme whereby part of the bonus can be paid tax free.

Personal tax is a complex subject and becomes more so with owner directors, schedule-D taxpayers (freelancers), and so on. It is always worth taking advice from a qualified accountant.

4.4 What Type of Organisation?

You are now reasonably sure that you have the main ingredients of a design business – the participating members or partners and an order book of potential business. Your next move is to decide what kind of business organisation you are going to set up. The main choice is between a partnership and a limited company.

The prime factor in deciding which of these to opt for is that a limited company takes its name from the principle of limited liability under which the shareholders cannot be made to forfeit their assets outside the trading company (such as their house) should anything go wrong – except in very exceptional circumstances.

There is now no restriction on either designers or architects trading as limited companies, although it is only recently that this has become the case for architects. This whole area is a complex one and subject to changes from time to time, and it is therefore advisable to consult specialists, such as a firm of accountants.

It is not particularly difficult to set up a partnership or a limited company. In fact you can buy a company 'off the shelf' – a company already registered with an appropriate range of descriptions as to the nature of the business to be undertaken. Applying for registration of a new company is also quite simple, but takes a few weeks. There are a number of specialists in company registration who will do all the paperwork and make the necessary applications for you.

Three examples of registration companies are:

Express Company Registrations Ltd
Epworth House
23-35 City Road
London EC1
01–588 3271

J P Company Registrations
New Companies House
17 Widegate Street
London E1
01–247 5566

Capital Company Services Ltd
1-3 Leonard Street
London EC2
01–251 2566

4.3 An Order Book of Potential Business

Without commissioned projects no design business can succeed. At the start you will need to be convinced that you either have sufficient work to start with, or you have good reason to expect to win some in the very near future. You need this not only for your own peace of mind but also, even more important, you will need it to raise finance to cover the first period of trading during which you will be paying out more than you will be receiving – more of this later.

In drawing up an order book, identify all the client contacts you have and the projects that are likely to come your way. Show how the work from these projects will be spread over the next few months in terms of the value of man hours to be worked. Differentiate clearly the definite projects, the probable work, and those that are only possibles. Be very careful not to fool yourself into thinking that projects are more likely to happen than is actually the case – even if you can impress your bank manager in the short term it will be you who suffers in the end.

An example of an order book is given below. This indicates that X.Y. Designs has definite fee earnings of £20,500, probable earnings of £12,000, and possible earnings of £27,500 in the first six months. In order to put this into a financial plan you would have to make assumptions about how likely the various projects are to be undertaken, and also assumptions about your ability to add new projects to the list during that six-month period.

Client	Project	April	May	June	July	Total Definite	Probable 1st 6 months	Possible 1st 6 months
ABE Ltd	Brochure	1,000	1,000	500	–	2,500	–	2,500
CDE Ltd	Packaging	2,000	–	2,000	1,000	5,000	–	–
EDG Ltd	Store design	3,000	5,000	5,000	–	13,000	7,000	–
GH Ltd	Furniture	–	–	–	–	–	5,000	10,000
IJ Ltd	Restaurant	–	–	–	–	–	–	15,000
TOTAL		6,000	6,000	7,500	1,000	20,500	12,000	27,500

Figure 4: an example of an order book

4.2 Strengths and Weaknesses

One of the most valuable exercises in strategic planning is to do an analysis of the strengths and weaknesses of your business and the opportunities and threats it is faced with. This is known as a SWOT analysis. Below is an example of such an exercise:

X.Y. DESIGNS LTD

STRENGTHS	WEAKNESSES
Design ability	Limited packaging portfolio
Retail experience	Low level of promotion
Strong management	Limited marketing ability

OPPORTUNITIES	THREATS
Own-brand packaging	Number of competitors in retail design
New areas of retail design	Competitors marketing skills in packaging
Recruitment of marketing staff	High salaries of marketing staff

This exercise gives you the chance to put down clearly and simply the key points to be addressed in order to move your business in the direction you want. In the above example the company has strong retail connections but a poor track record in packaging. A clear opportunity exists to do own-brand packaging work for retail clients but in order to beat the competition it appears that marketing expertise is required. The opportunity to expand this side of the business is therefore recognised, but at the same time an investment in marketing salaries must be allowed for in future financial planning.

This is a very simple example of the use of SWOT analysis, and there will probably be three or four conclusions of this nature that can be drawn. The key to using this kind of exercise is to look for things that you can influence and pick out just a few priority objectives which are achievable.

Once you have established these priority objectives, two more steps need to be taken. Firstly, check out the ramifications of attempting to achieve them in the overall financial plan – some things may just not be immediately affordable. Secondly, if you commit to achieving an objective, clearly identify whose responsibility it will be to make it happen so that they can build it into their workload for the coming period.

you will probably spend more of your waking hours with your business partner than with your marital partner. With a business partnership it is essential to base the relationship on ability and specialisation rather than on friendship. While it helps if you like your partner, it is more important to respect and believe in his or her contribution to the overall offer.

It is still most common to find designers teaming up with each other, and initially with designers from the same discipline. This has the advantage of allowing you to cope with larger volumes of the same kind of work, but is it the best combination for building the business?

Some very successful partners in the design industry have combined broader-based talents and experience. The design business is developing – just as the advertising industry did twenty years earlier – in such a way that it can offer a more professional service to its clients. Specifically, marketing and management skills are taking up a much more significant position or priority in the overall design-consultancy offer.

The design businesses that get into trouble often do so because the directors' skills are entirely design based, and they have not seen the need for strong management. The cash may flow into the business if the design offer is good, but if the cash is allowed to flow out uncontrolled there may be no business left before too long.

Similarly, design businesses can be started when a project or client is identified that can bring sufficient work for the first few months, but if the new business is not promoted, if the service is not marketed intelligently, that business is likely to have a very bleak future.

So, one alternative to partners from your own discipline might be to consider someone with a marketing or general management background. Another might be to look for someone from a different but complementary design discipline – graphic and interior design, for example – although achieving the right balance of work for two different disciplines when the business is very small can be fraught with problems.

The other side of the equation in seeking the right balance of partners is that of personality. Opposites can work well together as long as there is mutual respect and shared principles.

For example, if one person fights hard for every detail and is very aggressive, his best partner may be someone who is much more easy-going and calm, but perhaps has other strengths or human qualities which bring balance to the relationship.

Many businesses start with more than two partners. This creates a much more complex pattern of relationships and may be a great deal more difficult to handle. However, it does have the advantages not only of spreading the burden of responsibility for the new venture but also of providing a broader range of 'targets' for your frustrations. Furthermore, you will receive in return a wider variety of views and approaches from your partners.

Chapter Four

Starting a Business

4.1 Partners and Philosophy

If you are contemplating starting a business – and that includes being a freelance designer – the first thing to do is to take a good look at yourself.

Are you capable of running your own business? Not everybody is. Not everybody can take the pressure of working all hours to get a job done on time and then having no work at all for a week or two and worrying that you might never get that next project to help pay the rent.

Freelancers working on their own, with their own projects, their own clients and their own overheads, are most susceptible to this kind of pressure. The burden of finding the work, dealing with the client, doing the work, and running the business all fall on one pair of shoulders. Furthermore, when there is no work to do there is no-one else around to build up confidence and boost morale.

Some people are well suited to this life, and work entirely on their own, building up their own clients. Others remain freelance but work through an agency on a hourly basis, hired by larger practices. This has the advantage of greater security and a more constant supply of work, but the problem with 'temping' is that you will never have any real opportunity for growth. You will not lead a project, gain the full breadth of experience, or have the chance to build up your own business.

To some extent it is possible to combine freelance design work of your own with temping. While this would appear to offer you the best of both worlds, it will tend to draw you towards more and more temping so long as the industry is busy, thus giving you very little time to develop your own clients – and therefore your own business.

So, if you are starting from scratch, what is the alternative? In simple terms it is to find a partner or partners. The form of agreement between partners (usually a partnership or a limited company) is dealt with later. However, the first and most important thing to decide is who are likely to be your best partners and why.

Going into business with someone is as fundamental decision as getting married – in fact

Middle management taking up the reins may have less commitment to the scheme – they have inherited rather than originated and it may well mean extra work for them.

If you take on middle management in a fight to retain the integrity of the scheme, the senior executives may back their managers rather than you.

New managers taking over on the client's team are likely to suffer from the 'Not-thought-of-here' syndrome.

A senior member of your own team, such as a project leader, leaving will cause problems for design directors and designers trying to cover for him.

A design director trying to withdraw from the project may find the client pulling him back in. You need to wean the client off the design director and onto the project leader.

3.12 Keeping in Touch

Keep the client informed at all times. Let him know of any changes.

Minute meetings, 'phone or write to update, let the client know of any changes that effect fees or bought-in costs.

Use standard forms for building-contract supervision – drawing record and issue register, variation/instruction sheet. Copy to client.

Get clients to check and sign artwork.

Invite your client to spend informal time with you.

3.13 Developing Client Relationships

In the early part of the project enthusiasm is high on both sides. Use opportunities to regenerate enthusiasm later on.

Sometimes crisis point leads to difficult decision between integrity and client.

Opportunity may arise for individuals to act as consultants – design consultancy on all design work and business development consultancy.

3.14 The Second Sell

Do not miss out on additional business from existing clients.

Start with similar projects and then cross-sell into other sectors.

Use existing clients to sell to potential clients.

Project review meetings allow design directors and marketing staff to have input on design direction.

3.6 Project Familiarisation

Gather information about your client, his offer, the competitors, recent developments in the marketplace, research, trends, purchasing habits, etc.

Seek stimuli from beyond the constraints of the individual project.

On long-tern projects, learn politics of client organisation. Pin-point likely opponents and allies. Link into right ally with right level of authority.

3.7 Educating the Client

Get your client on board. Open his eyes to the potential of the project. Get him to experience relevant background.

3.8 Directing and Reviewing the Project

Avoid rolling your sleeves up and doing it yourself. Delegate properly and use supportive management techniques.

Brief properly and thoroughly, give information rather than conclusions.

Make your criticism constructive; use projects for training and development.

Use reviews for designers to experience presenting their work.

3.9 The Moment of Decision

Decision on overall design direction is usually put off.

Use reviews to analyse material produced by design team and precipitate decision on final direction.

3.10 Concept Presentation

Good structure and clear, confident presentation are as important as beautiful visuals.

Equal effort on background, reasons for direction taken and why it will be successful, as on visual solution.

Produce copies of presentation if client wants and can afford them. A small (sometimes 3-D) representation of a scheme to leave with a client can help to build commitment.

3.11 Changes in the Teams

Senior executives may move away from project

Summary and Checklist

3.1 The Contract

Find out everything you need to know in first contact meeting with client.

Respond with fee proposal – this is a selling document but also legal contract if your are appointed.

Fee proposal should be individual to your company, but should include:
Title page
Introduction
Brief
The team
The approach to the project
Programme
Design fees
Bought-in costs
Terms of business

3.2 Terms of Business

Standard terms of business should include:
Fee charges
Invoicing
Payment of invoices
Bought-in costs
Copyright

Check your client understands your proposal.

Get your client to confirm his agreement to the proposal in writing.

Avoid fixing fees where project not defined, and exclude revisions from basic scope of work.

3.3 Pitching

Avoid free pitching – potential fee earning does not justify investment in creative solution.

Paid creative pitch – set your own internal budget if fees offered do not cover your input.

Response to brief in form of marketing response and credentials presentation – again, budget your input.

Have clear understanding with your client for payment of speculative work if you win.

Copyright laws protect you from client taking free work and implementing it.

3.4 Royalties

Principle of shared risk and shared profit through payment of percentage on client's income.

Relies on trusting client and client's own abilities.

3.5 Programme and Team Selection

Identify members of team, project leader and design director – clear responsibilities for all identified.

3.14 The Second Sell

There is a great temptation to believe that once a new client has been won the selling stops and the designing begins. If the selling does stop you will be missing out on some of the easiest business to get and the most rewarding to do.

It takes a great deal of effort to win new business. It often takes a lot to even to get to speak to a potential client. So don't waste all that effort once you have got to know a client and are working for him. Not that he has to be aware that you are selling to him – certainly not to the degree that he becomes uncomfortable anyway. The timing of second selling is important too – not too quick or appearing to be greedy.

Getting to know your client allows you the opportunity to find out what his other activities are, what projects are in the pipeline, and who else commissions design projects.

The most obvious area to develop is work in the same field in which you have already established some credibility. The project you are working on or have just completed is the best vehicle for selling either to your original client or to his colleagues. Beware of being typecast, however. You will find it difficult to sell your other services anyway, so if you wait until you have completed three projects of the same kind you may find that your sudden switch to selling in a new area lacks credibility in the eyes of your client.

One way to open up conversations in a number of directions is to invite your existing clients to drinks or a lunch along with other clients, potential clients and designers or marketing staff from different areas of your business. Doing this gives you the opportunity to cross sell in a number of ways and to create new business from a variety of sources.

career, is suited to either kind of consultancy. The first requires a level of integrity and overview that few are capable of, and the second requires a mix of business and design skills rarely found in one person. But there are examples of both having worked extremely well and there is a chance that this kind of relationship will become more familiar in the future.

Fees for consultancy work are normally charged on a day-rate basis (or a monthly retainer to cover a given number of days each month). The level of fees a client will pay is related to the level of esteem in which he holds you. Suffice it to say that you should be providing very valuable input in a relatively concentrated period and therefore your fees should be at the top end of your charge scales.

3.13 Developing Client Relationships

Getting closer to your client will enable you to avoid mistakes, overcome difficulties when they do arise, and maintain enthusiasm on both sides. At the beginning of a project it is much easier to build up enthusiasm – it is new, everyone is meeting regularly and discussing it. Later on in the process it is easy for the energy to wane.

Use every opportunity to discuss the project in a positive way in order to maintain or regenerate the enthusiasm on both sides.

Occasionally a project may reach a point of crisis – you are pushing in one direction and the client is pulling in another. At this point you may well find that you are faced with a very difficult choice – to go on with the project even though it means going against everything you believe is right, or to resign the project in order to maintain your integrity but in doing so end a client relationship that could have developed and produced a lot of work for you.

The main thing to recognise is that the client who pushes you into a corner even though you are right is never going to respect you and the long-term relationship will follow the same course thereafter. Similarly, if you are wrong but keep pushing him, he will not respect you for that either.

At this point it all comes back to your philosophy and your attitude towards your clients. If you want to be respected as a consultant you must accept the consequences – you will lose some clients and potential clients who want to dictate rather than discuss or listen. On the other hand, if you want to provide a service and are happy to provide whatever your client wants then there is still a volume business in it for you.

If you follow the line of being a consultant there are two other possibilities that open up for you – consultancy on general design matters and business consultancy. There are very few design businesses that have achieved either of these relationships with their clients, and where it has been achieved it has usually been because of one or two individuals within the company whose input is specified as part of the consultancy agreement.

The first type of consultancy is one in which you review all design work carried out, not just by your own company, but by any other companies working for your client as well. In other words, you sit as an advisor to your client on all design matters affecting his company.

The second type of consultancy is ever rarer, but if you are able to offer it and persuade your client of its value, it can be extremely rewarding for both parties. Business consultancy or business development is normally associated more with management consultants than with design businesses. However, because design consultants are forever looking in to the future and because they are working in such a variety of areas, they can be in a unique position to identify business opportunities for clients.

Not every designer, even at the top of his

Figure 3: Variation/instruction sheet

Figure 2: Drawing record and issue register

3.12 Keeping in Touch

One way to ensure that the project and the client relationship run smoothly is the keep the client informed at all times. In general terms this means keeping up with your paperwork and letting him know of any changes whatsoever.

Whenever you have a meeting with the client or a meeting that, while not attending himself, he should know about, write up a set of minutes and copy them to the client.

Minutes of meetings should identify when and where the meeting took place, who attended and who is being sent copies of the minutes. The main body of the notes should deal with what was discussed and who should undertake what action as a result. It should not be necessary to cover the complete 'who thought what, who said what' of the meeting. If you feel that you have to record this information too it is usually a sign that the situation is becoming politically difficult – maybe you should be reviewing the project and deciding whether or not carry on.

From time to time throughout the project try to put yourself in the position of your client and think how you would feel at that time. If you think he might feel out of touch with the project give him a call or write him a short letter bringing him up to date.

If there are ever any changes to what had previously been discussed get in touch with your client. If there are any changes that affect the price your client will be asked to pay – and that includes your fees and outside costs – let him know immediately and get his approval to go ahead before doing so.

If you are managing a building contract, use standard forms for keeping in touch – this will remind you and your designers of the need to do so. The main two forms for this are the drawing record and issue register (figure 2) on which you should list all drawings completed or amended and to whom they have been copied, and the variation/instruction sheet (figure 3) which confirms instructions to the contractor, copied to the client, indicating items which could affect the final account.

With regard to printed matter, always get your client to check the artwork and sign to show that he has approved it. This will not excuse you making a mistake, but it should at least prevent any major blunders and will mean that any blame is morally at least if not legally shared.

Apart from keeping in touch through routine paperwork, which is not the designer's favourite job but which must be done all the same, do remember that clients usually enjoy working with designers and visiting their studios. So make time to get together with your client, invite him over and make him feel at home. You will find that the project will run much more smoothly if he knows you better and trusts you – which he will if you invest a little time with him.

very often as part of your internal team in order for the project to run its course, and yet the client may well want to refer to him and certainly will want to feel he is still part of the team. He will therefore have to keep in touch with developments and yet carefully wean the client off himself and on to the project leader.

3.11 Changes in the Teams

Even when the concept presentation goes well and all seems to be running smoothly, the development of the concept and the implementation of the job do not always move forwards without hiccoughs.

One of the reasons for this is often a change in the client's management team. Quite naturally, the creation of the design concept and agreement of the design direction are seen as the most important part of the design process and the client's team includes management at the highest level – people who may well have been responsible for originating the project in the first place. The energy and authority these people have can help you to introduce quite radical and far-reaching changes to the client company.

Unfortunately, the greater the degree of change, the harder it is for the client's middle management at the implementation stage – just at the time when senior executives have pulled out to do other things and left them to it. Middle management may well have inherited a situation they are not happy about, and they may not have been party to all the discussions and decisions that took place at the concept stage.

This leaves you in the position of pushing hard to keep the integrity of the concept while the client's middle managers are fighting off all the extra work they are faced with and the headaches you are causing them.

If you are imposed on the middle management by the senior executives this will suffice at the beginning, but sooner or later the confrontation will occur and by that time the senior executives will probably have turned to other matters. In addition, these executives will be faced ultimately with supporting their middle management (who they probably employed and are responsible for) or supporting you (who are outsiders and not seen as being needed in the long term anyway).

Another problem can arise where a new manager takes over responsibility on the client side for either the whole or part of the project. Having not been involved at all in the design process, he immediately tries to 'improve' it or change it. This is partly due to the 'not-thought-of-here' syndrome – in other words 'I do not like it because I did not think of it' – and partly due to his need to prove himself and therefore to be seen to be making a contribution.

Finally, it can be equally upsetting for the project if a member of your own team has to change. If the project leader leaves your employment, for example, it will be difficult to introduce someone new into that position (even if you have someone available). If you do not do so it will mean your design director at one end, and your designers at the other, trying to cover for the missing link.

Again in terms of your own team, it is often a difficult time following the concept presentation for the design director. He is no longer needed

3.10 Concept Presentation

It may be hard for a designer to accept, but when it comes to presenting a concept to a client, a well-structured presentation confidently and clearly presented is more important than a beautifully coloured-up visual.

More than at any other time in the project, the presentation of the concept to the client is the time to remember you are dealing with a layman, a non-designer who, even if he understands and likes the visuals you show him, will not be convinced by these alone. He wants to hear why your design solution is right, and he wants to know that you have thought about it – not just done it because you happen to like the look of it.

Spend as much effort, therefore, on presenting the background to the project, the reasons you have taken a particular direction, and the reasons why it will be a successful solution as you do on presenting the visual solution itself. Allow yourself enough time to pin up the presentation, familiarise yourself with it and rehearse it. Rehearse it properly too – in front of one of your colleagues or even a video camera if it is a really important presentation.

The client wants to feel that you are professional, and you will let yourself down if you mumble and stumble through your presentation. If your client contact has superiors who will be attending the presentation you will also be letting him down in front of those he wants to impress – and that will take a long time for you to live down.

Think also about the purposes for which your presentation material might be needed in addition to the presentation itself. If you want to use it for promotional purposes make sure you have it photographed. If your client would find it useful to refer to the presentation afterwards, find out if he would like to have a copy of it in a reduced format – but remember to warn him that colour prints are expensive!

Finally, it is sometimes appropriate to produce an example of the concept in a tangible form. Small models, three-dimensional representations of symbols, samples produced by sign manufacturers and so on are very 'sexy' objects and can be a great way of leaving a client with something to be pleased with. If the object is small enough you can bet it will end up on his desk, mantelpiece or window sill – and while he is enjoying it he will be increasing his commitment to it.

3.9 The Moment of Decision

There is a moment all designers avoid and yet must face. Sometimes it is a moment you have to make them face at reviews. This is the moment of decision. Every project involves several moments of decision on elements of the design solution, but there is always one major decision regarding the over-all direction that the solution is going to take.

The problem arises because you are striving for the best solution, not the first solution. Once you have taken this approach you have created the problem of recognising the best solution when you have produced it. The longer you work on a project the closer you get to it, and the more solutions you produce the more difficult it becomes to keep a sense of what you should be aiming for.

What makes it even worse is that designers are also driven by a desire to produce volume in order to justify the time spent on the project. If you can help designers to overcome their paranoia and spend more time thinking and less time drawing, then they will find that the best solution comes much more easily.

From the point of view of the programme and profitability of the project it is critical to face the moment of decision sufficiently early on to avoid either missing the deadline or throwing designers at the project in order to finish – inevitably going over budget. The review meetings allow you to bring the project to a moment of decision (if this has not already been reached) at the right time in the overall programme.

Remembering that producing a design concept is an intellectual as well as a visual exercise will help you to reach design solutions more easily. Do not be afraid to put words as well as drawings onto paper.

changes or comments.

You will find that designers are nervous about presenting their work to you. Use the opportunity to develop their presentation skills. Get them to treat you as a client, to explain the logic behind their design direction, and to present the story clearly and confidently. This will be very useful when they develop and are promoted to the point where they will be presenting to clients.

3.8 Directing and Reviewing the Project

As your company grows and your role develops more into directing others than doing it yourself, one of the hardest things top learn is how to balance your need to let others develop and learn and your desire to show them how to do it.

There is nothing more frustrating than watching someone else going round in circles when you know you could achieve the end result by going in a straight line.

If you are tempted to jump in and do it yourself, do not do so unless there really is no alternative. Firstly, you will be spending your time doing a job that someone else should be doing, and at the same time leaving something else undone which you should be doing.

Secondly, you will not be allowing your designers to learn their job by experience. Think how you learned in the first place – probably more by doing something yourself than by listening to someone else telling you how, let alone watching them do it for you.

Thirdly, if you stop your designers pursuing alternatives you may miss a design solution which could be better than the one you were moving towards in your straight line.

The difficulty and frustration in a commercial business is that allowing designers their heads costs money, whereas dictating the solution to them is likely to be very profitable. The route you take must reflect your philosophy and approach to your business. Whichever route you take, try to be consistent despite the occasional frustrations – otherwise your designers will not know whether they are coming or going.

If you want to let your designers work independently but want to avoid major frustrations, you will have to learn the techniques of supportive management and delegation. This means spending time with them at the start of the project giving them a thorough brief and guidance on how to approach and plan it.

You must allow your designers time to get to know the background as well as you do – do not keep anything to yourself. If you have been involved in early discussions with the client which they have missed, spend time to pass on the knowledge gained from these discussions thoroughly and carefully.

In briefing, try to give them information rather than conclusions, although it sometimes makes sense to pass comment on things that you feel are given, unchangeable or inevitable, so as not to waste time down blind alleys.

At the reviews, when the designers present their thoughts and design direction to you, be constructive in your criticism. Help them to look at the project in the right way, don't just help them towards the right solution. Ask questions which will lead them towards the discovery of the right direction themselves. This is an opportunity to train your designers to tackle projects better – so next time you will not have to make so many

3.7 Educating the Client

Apart from learning about your client and his business in the early part of the project, it is often necessary to prepare your client for what is to come. Nobody likes change and your client may not easily accept what you propose as a design solution if he is not 'on board' with your thinking. This is particularly the case with either more radical solutions or concepts for age groups or markets outside the client's normal field of vision and understanding. In order to get your client into the right frame of mind to understand and accept your design solution you may have to educate him and open his eyes to the potential of the project.

The minimum requirement is probably for you to begin your presentation with some background and attitudes before presenting visuals – see later under 3.10. However, it may also be useful to take key members of the client team through an educational exercise prior to the presentation. At one extreme this might mean taking them on a trip around the world to see what is happening in Japan or Europe. Equally they might benefit from a visit to a night club or restaurant where the target market go for their entertainment.

A great deal can also be achieved by setting up a seminar for the client team and presenting the media influences, shopping habits, social influences and so on that are relevant to the project and the target market. This can be a useful forum for involving their advertising agency, PR consultancy, research company and other consultants, not just to listen but to take part.

At this level of education of course the cost of the exercise can be very high and to most clients prohibitive, but it may be worth proposing to them you just might be pleasantly surprised at their response.

convert someone to your cause who is in a much stronger position to help you in the long run.

Try to find out who is respected within the client company, who is seen as having prospects, who is seen as successful. Sometimes you may even have the opportunity to give someone a 'leg-up' – you may recommend that a middle manager should have direct access to the chief executive in order to help you to achieve the right results from the design exercise. If you have made the right judgement about both the overall situation and the selection of the individual, then this should not only help you to reach a successful conclusion to the project, but at the same time you should also have an extremely helpful ally in the right place and with the right scope of authority.

3.6 Project Familiarisation

In the early stages of any project you will need to spend time gathering information, confirming the brief, absorbing the background to the project, understanding the culture of the client company, and analysing how to use this information to help you direct the project.

On a small and relatively straightforward project this process may take very little time and could even be achieved in one meeting with the client. But more often than not you will need to spend some time looking at your client, the 'offer' they are making to their customers, the competitors, recent developments in the marketplace, specific research on the customers and general trends in society, purchasing habits and so on.

You should also be seeking outside stimuli and influences, not necessarily directly related to the project, but anywhere that lessons can be learned or ideas stimulated. This is a process that cannot wait for a project but should be carried out all the time by designers through travelling, keeping their eyes open, taking photographs, keeping tear sheets from magazines.

Where a project is likely to be long term, complex, and difficult to introduce to the different departments or individuals within the client company, the project-familiarisation period gives you another very important opportunity – to learn the game of political snakes and ladders. In other words, establishing the potential opportunities and pitfalls within your client's organisational structure.

Unfortunately, in these circumstances, it is not necessarily the quality of a design solution that will win the day – although it will obviously play an important part. Even a good solution can fail to be implemented if it is not sold in properly.

You will need to find out who is in favour of the change you are trying to introduce to the client company and who is against it. This in itself is not easy because you will often find the long-term opponent to be initially very friendly and apparently helpful.

Try not to make enemies early on so that you give yourself time to open as many doors as possible and find out as much as you can. Eventually you will find you cannot please everyone and may have to accept a degree of unpopularity in certain circles in order to fight for what you believe in.

As an indicator of what to look out for when trying to spot a future opponent, think about who may be nervous about your presence – someone who has been looking after the elements you are now changing, someone whose quiet life is about to be disturbed, someone who does not see the reason for change, someone who would like to see the back of you.

At the same time, you will also find supporters of your cause. Be careful. Do not immediately cling to the most helpful person – he may not be in as good a position to help you as someone else. By concentrating too much time on your immediate ally you may lose the opportunity to

WEEK COMMENCING	May 5	12	19	26		June 2	9
Briefing meeting Project familiarisation	5 ▬▬▬▬▬▬▬▬▬▬			B A N K			
Design sketches trading name		▬▬▬▬▬▬					
Internal review			20				
Preparation of concept boards			▬▬▬▬▬	H O L I D A Y	▬▬▬▬▬		
Final review						3	
Preparation of presentation						▬▬▬▬	▬▬▬▬
Rehearsal of presentation							11
Client presentation							12

Figure 1: Project programme – stage 1

for the overall length of the project. Whichever way it is done you should highlight specific deadlines, meeting dates, review dates and so on. Also, do not forget to mark on bank holidays, designers' holidays and any other potential downtime.

3.5 Programme and Team Selection

Once you have been awarded a project you must plan out the following days and weeks carefully. Time slips by so easily, particularly when you are busy, and you must ensure that you set and keep to deadlines. Even worse, in terms of your company's performance, is the potential problem of a project drifting out of control with days being spent wastefully.

If you have not already done so, select your team. On small projects this is very straightforward – one designer is both responsible for and carries out the project, possibly calling upon more junior or specialist staff if appropriate.

On larger projects – particularly on multi-disciplined ones such as retail design – the balance and the structure of the team is critical. You must identify clearly the project leader and design director responsibilities. The project leader will be full time (or as much as the project requires) and will lead the team day to day. The design director will from time to time check the progress and direction of the project.

In a small company with few projects both these functions may be performed by the same person. Even in these circumstances it is helpful to remember you are fulfilling two roles – don't forget to stand back and take an overview, even on your own project.

In a larger company, where the functions are performed by different people, it is necessary to build into your programme opportunities for the design director to review the project. Make sure that these are meaningful reviews and that you have allowed enough time for amendments and adjustments between the review and the next meeting or client presentation.

On multi-disciplined projects you may need to identify more than one leader – normally a team leader from each discipline. In most cases it is still necessary to identify one of these as the overall project leader in order to establish clear responsibility for the day-to-day running of the project and to avoid drawing the design director in to play that role.

There are no hard-and-fast rules to help you decide on the right balance for the team – this will only come with experience. However, the proper programming of a project with built-in review meetings will enable you to avoid any major mistakes and to make the most of your more experienced designers.

If you employ marketing staff who are able to make a contribution to projects, the internal briefing and internal review meetings are your opportunity to introduce them to the project direction process and at the same time make good use of their time.

Figure 1 gives an example of a project timetable for the first two stages of a multi-disciplinary project. In this case they have been defined as Stage One: Project Familiarisation; and Stage Two: Design Concept. Programmes can be shown in weeks or in days according to what is appropriate

3.4 Royalties

Occasionally you may have the opportunity to work on a different remuneration basis than straight fees. The chance to share the risk with the client but also to take a share of the profit if the project is successful is the principle behind a royalty agreement.

Many clients avoid royalty agreements – they believe they will be successful and would rather make a one-off payment than go on paying a percentage. When such agreements are used it is generally for product design and they are based on a percentage of the revenue at (usually) wholesale prices. This kind of agreement relies heavily on your trust of your client — you are after all in his hands both in terms of the good management of the project beyond the design process and the payment of the royalties that should flow your way thereafter.

disciplined about budgeting your input. Also make sure that it is a limited exercise from the client's point of view – in other words he has taken the trouble to select a good shortlist and is only asking two or three to compete.

In any pitching situation where you are spending an amount of unpaid time in order to win a project you should have a clear understanding with the client about what happens if you win the project. Given that the work you have carried out is useful and necessary to the success of the project, this work should be paid for by the client.

You will need to identify how, when and how much the client will pay for the speculative work as an individually invoiced item, or build the time into your fee proposal for later stages. If the client does not ask to see a fee proposal for the project at the time of pitching you will probably need to raise the subject of repayment for time spent yourself prior to undertaking to pitch.

You may also need to remind some clients in this situation of copyright laws. The point here is that a client cannot reproduce anything from the work you do for him unless he has paid to do so. The drawings and visuals that you produce are automatically protected by copyright. If a client has paid for the project he should be allowed to use the material you produce for the purpose it was intended. If there has been no payment or only part payment then copyright law should protect you.

3.3 Pitching

Advertising agencies, who now try equally hard to avoid free pitching, at least have a regular annual income to look forward to if they win and an income that is generally high enough to bring the cost of pitching down to a relatively low percentage of the expected earning from that client.

Design businesses do not normally have the same opportunity to earn fees over a long period of time and the investment of time in a creative pitch could represent as much as fifty per cent of the total potential earnings. Clearly this does not make commercial sense.

There are two alternative approaches which are a great deal more tempting to the design business and more moral from the client's side too.

The first of these alternatives is a paid pitch. Here the client announces in advance how much he will pay in the way of a rejection fee to each design business taking part. This gives the client the opportunity to see more than one solution but means that he almost certainly has to pay more than if he had selected one group straight away. It has also been known for a client to be more confused after seeing alternative presentations rather than clearer.

Whether it is right or not for a client to take this approach you will almost certainly be faced with the choice of whether to take part in a competitive pitch. The problem you are faced with is that the fees offered are unlikely to cover your full input and you will be tempted to over commit as well in order to try to beat the competition. If you decide to pitch, do it seriously but discipline your team by setting a strict budget to keep to.

The second route a client might take is to ask for a credentials presentation plus an attitudinal response to the brief – not the visual presentation of a creative solution but the response to a review of the proposition. In other words, the client is giving you the opportunity to take a closer look at his business and giving himself the chance to get a closer look at you and your competitors before choosing.

A credentials presentation will need to cover examples of relevant work you have carried out for other clients, how you have worked with those clients, how you approached the projects, and what your input was. At the same time you should describe your company, its philosophy, its size and structure, its strengths and ambitions.

Your attitudinal response should be based on the brief you have obtained from the client, your conversations with him (and the client's staff, if relevant), his customers, and any background analysis of the market you have gleaned. The client is looking to find out whether you have an understanding of their business and to gain an early impression of how you would approach the project.

As it is unlikely the client will pay for the whole of this exercise, you should be particularly

or not you are a member of either organisation.

Once you have submitted your fee proposal it is worth checking that the client has understood it – after all many clients are not accustomed to dealing with design and the terminology which is familiar to you may be incomprehensible to them.

When a client accepts your proposal and asks you to proceed with the project it is sometimes worth going through it again with particular emphasis on the financial and contractual elements as opposed to the selling elements.

Your proposal does act as a record of the agreement but it is always better to have written confirmation from your client that your proposal is accepted. An alternative to this is for both you and your client to sign at the bottom of the proposal. However, this smacks of legal documentation of a kind that might make your client nervous. He may want his legal advisors to see it and you may end up with an agreement twice as long in order to satisfy them.

To a large extent the relationship between design consultant and client will always depend upon trust rather than legal jargon and no design project can be defined so tightly as to leave no room for interpretation.

Finally, there are some basic pitfalls to avoid when defining the scope of work within a contract. Do not agree to make revisions within the scope of the basic project unless they are the result of your own errors. Any agreement that allows your client to go on asking for revisions or alternatives will cost you dearly.

Also, do not agree to fix your fees beyond the stage where you can define the scope of work. Some clients will push you hard to agree to fixed fees right through to completion of the project. On small, straightforward projects it may be possible for you to do this so long as changes and revisions are defined as extras.

On large or ill-defined projects agreeing fixed fees right to the end before starting can be very risky.

Ultimately your tendency to bend these rules will depend upon how much you want the job and what your judgement is regarding the trustworthy nature of your potential client.

3.2 Terms of Business

You will not be able to cover every element of how you work and the terms of which you do business in each proposal. It will therefore be necessary to have standard terms of business printed. The important thing within the proposal is to refer to your standard terms and to state that they apply to this project, enclosing a copy for the client to read.

You should arrange the order and style of your proposals to suit your requirements but make sure that the elements listed above are included.

With regard to standard terms of business, again you must write these yourself with a view to your own attitudes towards your business. The main headings you will need to cover are as follows:

FEE CHARGES
Confirm the different methods of charging and use the opportunity to explain them carefully.

INVOICING
Explain how you invoice and when whether this is at the end of each stage, monthly, at the end of the project and so on.

PAYMENT OF INVOICES
Make it clear when you expect your invoices to be paid (and it is worth repeating this on the invoices themselves). It may be worth mentioning what action you may take if invoices remain unpaid.

BOUGHT-IN COSTS
Indicate whether bought-in costs and expenses are charged in addition to fees, and whether a handling fee is charged and, if so, at what percentage.

COPYRIGHT
Confirm that you own the copyright on all work produced and indicate the circumstances under which you would be prepared to assign copyright, if any.

LIABILITY
Try to limit your liability to the value of work you carry out and avoid any liability for consequential loss.

It is worth noting here that, whether you cover it in your terms of business or not, you have some protection under the law of copyright. However, it is not the clearest of legal situations and may be hard to enforce. Generally speaking copyright covers items actually produced, such as drawings and photographs, rather than ideas explained or expressed.

The law on copyright differs from country to country and the UK law is under review at the present time.

Standard terms of business are available from the main industry bodies – the DBA and the RIBA. These can be purchased for a few pounds whether

committing yourself to an overall level of fees for the project, your client will almost certainly have to budget some amount for the project anyway for his own internal controls. If he sets a budget which is lower than you need to complete a project then you will have a problem anyway. So you may be better off at least giving an indication of your estimated budgets – probably as a range (for example £20,000 to £25,000).

BOUGHT-IN COSTS
Materials, expenses, bought-in services, specially commissioned illustration or photography, travel and subsistence are usually required to some extent on all projects. You will normally want to charge these to your client over and above you design fees (which in themselves are only calculated to cover your design hours). You will probably also find it impossible to judge how much will be spent on these in advance. The most important thing to do in your fee proposal is to highlight the fact that they will be charged in addition to design fees, and how they will be charged (with or without a handling charge – see section 5.3).

Managing Projects and Clients 25

the client side it has been prepared, who wrote it, and the date.

INTRODUCTION

This is your opportunity to confirm your understanding of the situation regarding the background to the project, and to give a short summary of the design brief. This has the dual role of confirming to the client that you have been listening and are reasonably intelligent and at the same time acts as as a very useful initial briefing document to your designers who will join the project team once the job gets under way.

BRIEF

It is sometimes appropriate to give a more detailed account of the design brief and it is logical that this should follow on from the introduction. It does not necessarily have to form part of the fee proposal, however, and sometimes has not even been established sufficiently well to do so.

THE TEAM

If you can, and you want to, identify the team of designers who will work on the project, this can be helpful as part of the selling message. A summary of the senior members of the team and their experience can help to assure the client of your capabilities. Be careful though. Once you have committed your team you had better be able to go through with your promise whatever other work has come in since writing the proposal.

THE APPROACH TO THE PROJECT

This is your opportunity to lay down the stages into which you would break the project and the scope of work you would undertake at each stage. Be very accurate and choose your words carefully. Make it as clear as you can what you intend to do and what you do not. This part of the proposal is a key component of the contractual side of the document. Try to define clearly when a stage is completed – not by putting a date on it, but by describing what you consider to be the work that completes the scope of work for that stage. This may not always be possible, but if you can do it you will avoid some awkward moments.

PROGRAMME

Where possible lay down the timescale for each stage. If you can put dates to the programme this will allow you to arrange key meetings more easily – internal meetings, client meetings, and presentations. If you cannot fix dates, at least give an indication of timescales in terms of numbers of weeks required.

DESIGN FEES

Give a clear description of how much you would charge for each stage, on what basis you would charge, and what costs are excluded. The basis of charging will normally be fixed fees, hourly rates within a budget, or a percentage of a building contract.

Although your inclination may be to avoid

Chapter Three

Managing Projects and Clients

3.1 The Contract

When a client asks you to undertake a project a contract takes place between you and your client. It is in the interest of both parties to understand clearly what is being offered and at what price. Both parties want to see the contract completed successfully – to their mutual satisfaction. The best agreements are those which are both clear and fair. All being well, both parties will wish to do business with each other again some time in the future.

When you first discuss a project with a client it may not yet be certain whether you will undertake it or whether it will be given to one of your competitors to carry out. Even though it is uncertain at this stage, always treat the conversation with the seriousness you would give a definite project. Go into the background as thoroughly as your client will permit, and gather as much detailed information as you can.

At the end of this first discussion it is likely that you will be asked to respond in writing with a summary of the project as you understand it, your approach to the project and how much you would charge. This proposal of fees and description of the project will, if the client asks you to undertake the work, form the basis of the contract. During the project both parties will need to refer to this document from time to time in order to determine the scope of the work agreed at each stage of the project and the fee arrangements, as well as other smaller but sometimes very important details regarding responsibilities.

All fee proposals vary according to the nature of the project and you will want to stamp your own practice's personality on it as well – after all, it is not only a contractual document but also a selling opportunity. However, the headings given below are a good indication of some of the key ingredients.

TITLE PAGE
This will differentiate one proposal from another using a very short (one sentence) description of the project. You should also identify for whom on

2.7 Indirect Promotion

Indirect approaches – industry bodies, conferences, seminars, exhibitions.

Media coverage – advertising and PR.

Key points for press relations:
1. Push unique stories hard
2. Don't dictate to journalists
3. Build relationships with editors; be helpful
4. Be daring
5. Control clients' veto
6. Be brief and astute – first three lines of a story are the most important
7. Tailor stories to specific media
8. Basics of press releases:
 - double space text
 - date
 - contact name and telephone number
9. Good black-and-white photography

2.8 Building your Portfolio

Get samples of work, take photographs – preferably good-quality photographer.

Record the full story – previous versions, early visuals, final design.

Marketing and Generating New Business

Summary and Checklist

2.1 Marketing and Design

Identify target market.
Establish requirement of that market.
Tailor your offer to fit requirement.
Promote the offer to the target market.
Repeat for other target markets.

2.2 Targetting by Sector

List all target markets and group under sectors according to the size of your business.

Define different client types within each client company.

Use SWOT analysis and integrate philosophy and approach to the business. Look for a fit between you and your potential clients.

Use sector marketing to offer credible specialisation but maintain overview and cross-sell between sectors.

2.3 Building on your Strengths

Start where you have experience and feel confident, where you have some success stories and, therefore, credibility.

2.4 Filling the Gaps

For the long term, work on breaking into new areas.

2.5 Be Prepared

Always check out your potential client and his market, his competitors and his customers, before the new business meeting.

Sources of information:
1. Trade publications, magazines, etc.
2. General company directories and specialist sector directories.
3. Specialist reports.
4. Information services.

2.6 Selling Techniques

Select your potential client companies in each target market. Pinpoint the right client type and the right individual.

Direct approaches – letter, mail shot, 'phone call, personal visit. Cold calling and door-to-door selling inappropriate to design consultancy.

1.8 Building up your Portfolio

Something to concentrate on, and inevitably to spend money on, is building up your portfolio. If you are designing brochures it may simply be a question of making sure you get samples from your client, and the same with packaging – but even here you are probably better off having some good photographs taken.

Certainly with environmental work, retail design, product design and so on, you really have to accept the fact that if you want something to show for all that hard work you will have to pay someone to photograph it.

Architects have rarely considered the need to have a good photographic record as a selling tool and consequently have slipped behind in recent years in the race to establish a presence in the design field.

Finally, do try to ensure you have a record, not only of the finished job, but also of the initial visuals and what the product was like before you redesigned it (if relevant). This will give you a much better story to tell when you really want it.

publications more avidly – such as their own trade press, the marketing press, and the national press. Here you will have to generate stories which appeal to an audience that is not primarily interested in design.

How best to handle PR is not an easy decision. A good PR consultancy will offer a professional and effective service but will charge fees that most small design or architectural practices would shy away from – perhaps £1,500 to £3,000 per month.

An alternative is to employ a PR specialist yourself. Again, this can be expensive and small practices will not have enough work to keep someone busy.

Very often the principals of the design company can at least forge links with the design press and with administrative help they can achieve a limited degree of success. If you are in the position of having to tackle this yourself, the following key points may be of some help:

Look for unique stories and push them hard – don't pester journalists to cover dull stories; they will probably tire of you and you will miss your chance when you do have a great story.

Don't dictate to the journalist – don't insist on photographs, front covers, particular phrases in the text – remember how you feel about people dictating how you should do your job.

If you have the chance to comment on the text correct facts, not the style.

Build relationships with editors if you can – be helpful; supply information when you are asked for it.

Be a little more daring than you first think you should – journalists are looking for good stories and good quotes, something to get their teeth into.

Try to control clients' instincts to veto – remember that their best interests are not necessarily yours.

When sending material to the press make it short and astute – the first three lines are the most important.

Tailor stories to particular media and if possible give exclusives (rights to all or a part of your story to one publication). Study the stories covered by each publication to discover what they are interested in.

Remember the basics about press releases:

- Double space your text
- Put a date on it
- Give a contact name and telephone number.

Most coverage is in black and white, so remember to take good black-and-white photographs (black-and-white reproduction of colour photographs is inevitably poor quality).

2.7 Indirect Promotion

Apart from direct contact with identified potential clients, there are a number of supplements or alternatives. There are some industry bodies which have a selection service – clients go to them looking for designers and are given an appropriate shortlist to go and see. Such bodies include the Chartered Society of Designers (CSD) and the Royal Institute of British Architects (RIBA). In addition, you can join the Design Business Association (affiliated to the CSD but specialising in design businesses rather than individuals) which may also make referrals. For architects the RIBA offers a similar referrals service.

Some of these services are offered free with membership, while others are subject to a special fee for being on their lists.

Conferences and seminars can bring you into contact with potential clients, but they are time-consuming and sometimes expensive. Exhibitions can also be a source of information and sometimes personal contacts can be made – although not often at the right level (the manager responsible for a project will rarely man an exhibition stand). A list of the main exhibitions being held in the UK and overseas is published by the Department of Trade and Industry (DTI) as a special supplement to their 'British Business' publication every quarter.

Finally, you can try to 'spread the word' through advertising and PR. Advertising can be effective but it is expensive – particularly when you consider the saying that 'half of all advertising is effective, but you never know which half'. Also, it comes and goes quickly for the investment you make.

PR is probably a much greater opportunity, but remember that very few journalists really want stories about design businesses (except occasionally as a review of publically quoted ones), and therefore it is your clients they want to hear about, not you.

Bearing this in mind, you must be careful not to waste your time preparing stories that have no real PR potential – you will only be disappointed when the journalist does not cover it.

On the positive side, there is now a strong design press in the UK, and some clients are beginning to take an interest in these publications too. It is well worth starting with the design press because they are much more likely to cover your story.

The main publications in this field are: *Design Week, Creative Review, Direction, Designers Journal, Design, Blueprint, Architects Journal, Architectural Review,* and *Building Design.*

The coverage you receive here will at least begin to establish your reputation within the industry and help with recruitment (everyone likes to work for a practice with a good reputation). Clients may see your name here from time to time and this will help you to gain credibility in their eyes too.

However, clients will probably be reading other

2.6 Selling Techniques

A large part of successful selling is a question of perspiration rather than inspiration. Occasionally you come up trumps with a piece of inspired guesswork but most of the time it is a question of thorough research of the market and the right approach – or, very often, several approaches over a period of time.

Having identified a target market, your first move is to find the right client companies in that market – not necessarily the biggest, but those you believe would fit with your approach to the business. Then you need a name. Finding out the right person to talk to never turns out to be quite as easy as it should be.

Remember that we have already established that there could be a number of client types within one company. So you have to be very specific in your understanding of who you are looking for and in your questioning of the switchboard, secretary, or whoever you are asking for information.

Then you have to decide on your approach. A carefully worded letter may be a good introduction to one person, whereas another might just take it as a warning signal and be ready to have you blocked or redirected when you follow up by telephone.

Sending some printed matter is usually an improvement on just a letter – but not always. One thing is for sure: you won't get many replies unless you follow up.

An alternative is to avoid letters, mail shots and the like, and opt instead for the direct 'phone call or personal visit. However, although this can be effective for some businesses, it does not seem appropriate for a design consultancy. One feels that a consultancy should not need to 'tout' for business in this way – a doctor or solicitor would not do so. Perhaps a studio design service might be promoted like this, but a consultancy requires a more subtle, more authoritative approach. You will have to decide to right strategy and the right tone of voice for your business.

2.5 Be Prepared

Whether you are approaching a potential client in a familiar or an unfamiliar target market, do your homework. You will be on much stronger ground when you meet if you know a good deal about his company, his competitors, his customers and his market potential. Many clients have come to expect this anyway and will not be impressed if you are not prepared.

If he is a retailer, go to see some of his outlets. If he is a marketeer, buy some samples of his product and his competitors' products. Find out as much as you can about him and his company before the meeting.

There are some excellent sources of information available – although these can be expensive. Many are accessible through public libraries at no cost (except your time).

There are four main sources which you could use to gather information on products, markets or companies. Firstly, the trade publications, weekly and monthly magazines, will give you a regular update on activity in particular industries. Also useful are the more general marketing magazines such as *Marketing Week* and *Marketing*. If you want to find previously published articles on particular subjects there are companies which offer a cuttings service and can supply this information.

Secondly, there are directories of information on companies and their activities. General directories include Dunn & Bradstreet's *Key British Enterprises* (an alphabetical listing of companies), *Kompass* (companies by product and location), *The Times 1000* (companies by turnover), and *Who Owns Whom* (companies by group ownership).

Specialist directories are available for certain industries, such as the *Retail Directory* published by Newman Books.

Thirdly, information on particular markets is available from specialised sources such as Mintel, Euromonitor, and Keynote. They supply regular information and special market reports. The Henley Forecasting Centre publishes general and specific market trends and forecasts.

Finally, there are a number of organisations which supply an information service on a variety of subjects. These services are usually now computer-based and sometimes require you to have a terminal at your office. These suppliers include SVP, Harvest, Maid, Datasolve, and Infoline.

Many of the information services are only available to members and as membership fees can run into thousands of pounds you will have to be selective.

2.4 Filling the Gaps

For the long-term development of your business you will have identified some areas of current weakness but future opportunity. In order to fill these gaps successfully you will have to do some groundwork.

Unlike your areas of strength, you know relatively little about these new areas and will need to learn much more about them before feeling confident enough to win business against competitors who are likely to have much more experience than you.

This will mean an investment of time and probably of money as well. For example, if you had no experience of shopping-centre design but wanted to expand into this field you could join the International Council of Shopping Centres (ICSC) and go to their annual conference (it takes place in a different European country each year).

While this could be major source of potential work, it would be an extremely difficult area to break into and you might have to consider a two- or three-year period of learning and outgoings of up to £10,000 before you start to see any return.

On the other hand, if you have a good packaging portfolio with the exception of, say, cosmetics, and want to win some business in that target market, you should be able to get through the research much more quickly and at far less expense.

These are the kinds of choices you will be faced with and you will have to set your sights realistically, taking on only as many new areas at one time as you can reasonably cope with in terms of financial commitment and investment of management time.

2.3 Building on your Strengths

Once you have identified sectors, client types and so on, you need to decide where to start on what is probably an extremely long list of potential clients. The best way to achieve new business in the short term is to build on your strengths.

Look at the areas in which you have experience, where you have notched up some success stories, where you feel confident and have something to sell. While you don't want to work in the same field all your life, this approach will bring in some work to help pay for future development elsewhere.

It is sound advice, not just for design businesses but for all companies, to build up your core business first – this produces the profit to allow you to develop into new areas of activity. The exception to this might be where the market for your core business is shrinking (such as tobacco), but this is certainly not the case with design.

be concentrating on specific offers to specific targets. While this has immense advantages in improving your ability to identify and convert new business – i.e. to convince the potential client that your offer is right for him – it does make the organisation and co-ordination of your marketing activity more difficult.

Firstly, you have to THINK about the potential client before each approach. There are no half measures here – a lack of preparation will mean a lost opportunity. Failure to prepare is preparing to fail. Make sure the right client type is being approached in the right way. Tailor your approach to the requirements of the potential client, showing him relevant work and concentrating your questions and responses on his business rather than on yours.

Secondly, once you start thinking in terms of specialisation – i.e. once you start focussing your marketing activity and attitudes – you may start to lose your overview. Try to remain flexible and alert in your marketing, using the disciplines to your advantage, not to your detriment. So, if you are talking to a client company about one sector, don't lose out on the opportunity to cross-sell into other sectors.

In a small company where the marketing is undertaken by one or two people (often the directors or principals) the problem is less likely to arise because their overview is inherent in their position in the company. However, once the marketing role is delegated, the tendency will be for vision to become more tightly focussed, and special attempts will need to be made to link the individual sector views to the corporate overview.

will probably involve yet another client type in the field of corporate or office management.

This obviously makes the task of establishing the requirements of target markets very complex, but it does bring home a number of salient points. Firstly, it should help you to avoid making the mistake of dismissing a potential client as being a 'lost cause' just because of one difficult telephone conversation. There may well be other potential clients elsewhere in the client company.

Secondly, it highlights how important it is to be talking not just to the right company, but also to the right person, in the right way, and about the right subject.

Thirdly, it may well mean that although you are working for a client company in one area you will still find it hard to win projects in another. This is normally because of different client types dealing with different projects. However, it is frequently made doubly difficult by internal politics and jealousies within the client company. Working for one department or section of a company, rather than being a recommendation to others, may in fact be a turn-off.

So, you have identified client types, grouped them into target markets and established their requirements. Now you must look at your own service and see how you can tailor it to fit those requirements. This is where you can use a SWOT analysis (described in Chapter 4.2) to produce an analysis of your strengths and weaknesses for each market sector, and when doing so bear in mind what the target market is looking for.

At the same time, it is important to remember the overall philosophy and approach to the business. It is very dangerous to attempt to be all things to all people – you will almost certainly fail. It is better to accept that there are some people for whom you will never work and turn your attention to those who are looking for your kind of service.

So if one retailer is looking for mass implementation of a retail scheme involving hundreds of detailed drawings and site supervision across the country he will probably end up using a different design business to the retailer looking for strategic thinking for a brand-new retail concept.

Even if a design business were capable of producing both, few retailers would believe it. Apparently opposite services offered by the same team to the same client in the same breath lack credibility.

Credibility and integrity are precious commodities in the design business – they should not be wasted on a throwaway line in an attempt to pick up some additional work.

The final stage in the process of marketing your services is to promote your offer to the target market and to repeat this for each offer and for each target market.

The specific techniques of promotion to achieve new business are covered later, but an important point needs to be made here regarding sector marketing.

If you follow the approach laid out here you will

2.2 Targetting by Sector

First you must identify your target markets – in other words, break down your potential clients into market sectors. The best way to approach this is to list every type of client you have (or would like to have) and then group client types together to form market sectors.

When deciding how to group your client types into sectors you may have to take into account the size and structure of your own business – a large design practice will find it appropriate to have more sectors than a small one.

In order to help you to define your list, the following examples of client types and sector definitions may help:

Client	Requirement	Sector
Developer	Shopping centres	Retail
Developer	Office design	Corporate
Developer	Catering; Food courts	Leisure
Travel	Airports; Stations	Leisure
Retailer	High-street stores	Retail
Retailer	Out-of-town stores	Retail
Retailer	Own-brand packaging	Product Marketing
Marketeer	Brand packaging	Product Marketing
Marketeer	Product literature	Product Marketing
Marketeer	Exhibitions	Product Marketing
Board director	Corporate identity	Corporate
Board director	Office design	Corporate

A small design business may define only two sectors – say, corporate and commercial – whereas a large design business might have six or seven – for example, shopping centres and office design might become sectors in their own right.

The rationale for defining sectors is simply to enable you to focus your marketing activity. Your marketing will be effective if you think in terms of the type of client and his requirements.

It is important to be outward-looking when marketing your services. Use definitions based on your client's terminology, not your own. The fact that your staff may have trained as graphic designers, interior designers, architects, product designers and so on is ultimately not relevant to your client – he is looking for people who can solve his problems or help him to make the most of potential opportunities.

When establishing your clients' requirements you must consider the client type carefully. It is not enough to define a client as a retailer, for example, as there will be different client types within the retail client company. At director level the requirements will be strategic – reworking existing retail design or originating new retail concepts. On the other hand there will be marketing, buying, or design managers whose requirements are to do with packaging, promotion and point of sale. Between the two types there will also be a requirement for product development.

If that same retailer moves to new offices or wants to refurbish the staff canteen facilities, it

Chapter Two

Marketing and Generating New Business

2.1 Marketing and Design

Marketing is essentially identifying a target market, establishing the requirements of that market, tailoring the offer you make to fit those requirements, and then promoting the offer to the target market. This process can be repeated for any number of different target markets.

For example, a retailer's demands for packaging design are likely to be different to those of a manufacturer. The retailer with his outlets in place has the opportunity to introduce a large own-brand packaging programme using relatively well-known and well-tested market forces – his own retail environment, his retail identity and customer loyalty. This enables him to launch own-brand packaging without any major research programme. He can use his own buying and marketing team as the judge and jury on a new pack design.

With brand packaging for manufacturers the process is more complex for two reasons. Firstly, they are selling to two levels of customer – the store buyers in each retail chain they supply (or would like to supply) and the end-user.

Secondly, the end-users will probably not be the same for each of their products. This means that the manufacturer usually has to undertake a programme of research in order to ensure that the packaging design is well targetted.

The client's requirements in these two cases, although on the surface the same – i.e. pack design – are in fact quite different and you will need to adjust your presentation and fees to suit.

A design business is no different to any other business in that successful marketing is the only sure way of increasing the order book. Offering an inappropriate, unwanted service is a certain way to fail in business.

Equally, the right service at the wrong price will prove unsuccessful. Even achieving the right balance of service and price is not enough – you must tell your potential customers about your offer (they cannot use you if they do not know you are there). This does not mean, however, that you necessarily have to spend a lot of money on advertising or employ a large marketing team.

Marketing is about targetting and promoting, either directly or indirectly.

Summary and Checklist

Fundamental Principles and Strategy

Design businesses vary enormously in size and type. Some are famous through size and public quotation, some through reputation and personality.

Each has a strategy which may have been laid down purposefully or grown organically.

Alternatives to select from in setting a strategy are:

QUALITY OR QUANTITY
Being selective about clients and projects or not. Large quoted companies whose strategy is rapid growth find repetition more profitable (and therefore more necessary) than innovation). Selectivity leads to less profit and greater variation in staffing levels.

TOTAL CONTROL OR STAFF DEVELOPMENT
Dictatorship plus 'visualisers' is more profitable, but restricts growth of individuals and potentially of the business.

Delegation and staff development require more time and money, but 'growing your own' is rewarding.

ONE STYLE OR MANY
Some businesses have a strong handwriting which clients can recognise and ask for.

Variety of styles produces good relevant solutions, but is more difficult to manage.

The final strategy agreed upon will be a balance appropriate to the partners and should be discussed and agreed with honesty.

effective approach than waiting for juniors to make mistakes.

The great compensation for this investment of time and money on the development of your staff is that they will stay longer with your company and be more productive (and creative) at a lower cost than the 'additional dictator' approach – it is cheaper and more rewarding to 'grow your own' than to buy it in at the top.

ONE STYLE OR MANY

Some design businesses have a very individual style – a kind of visual handwriting which pervades all their work. The advantage of this is that potential clients have a clear idea of what is being offered and, if they like it, feel comfortable about commissioning a project. The problem is that it places a major restriction on the kind of projects the design business can take on and is very limiting for all who work there.

The approach that allows for as many styles as there are design solutions does produce a wide variety of good results for all types of project but the freedom of approach makes it much more difficult to control.

The above alternatives are described in very black-and-white terms. In reality the solution will inevitably be somewhere between the extremes. The task in identifying your strategy will be to strike the right balance for you and your partners in such a way that you can keep to the principles you have laid down even when faced with tough decisions.

your heart on your ultimate direction at the beginning you will not be the master of your own destiny. Be warned on this point.

You will be faced with a choice between these two options at some point – for example when a large project is offered to you which offers little creative opportunity and job satisfaction.

In certain circumstances these factors may be reflected in the whole company's ability or desire to elect to work on quality projects as opposed to large projects. In particular, a company whose strategy is to grow quickly using public funding will soon realise that repetition is more profitable for their business than innovation.

City investors and commentators are impressed by profits, not by how creative you are or how much you enjoy your work. Healthy profits should raise the price of your shares, which in turn allows you to acquire other companies and generally to act in an expansive and aggressive manner. This is a direction that a number of design and architectural companies have taken and the owners of those businesses have benefited from substantial financial rewards.

Other design businesses have foregone growth and opted for selectivity – the ability to choose whether a client or project is right for them. To carry this approach through consistently is likely to invite extreme fluctuations in the size and profitability of your business. When the right projects are not available you will have to trim your workforce as there will be no work for them.

TOTAL CONTROL OR STAFF DEVELOPMENT

Generally there are two ways of running projects as a company begins to grow – dictate the design solution yourself and employ juniors to 'work it up' or delegate the total task to others, briefing them well and helping them to reach the right solution.

The latter requires an investment in the development of your staff and will almost certainly be less profitable.

The dictatorship approach enables the experienced designer to arrive at a solution more quickly and with less 'wasted' time. The problem is that those working for him will be used only as visualisers, thus learning little in the process, limiting their growth as individuals and therefore the potential for the company to grow (unless additional 'dictators' are brought in from outside).

On the other hand, to give junior designers their heads on a project does inevitably lead to a less 'efficient' working arrangement because it allows them to learn from their mistakes rather than from observation alone. The managing designers will spend more time putting right the mistakes that have been made by the juniors, which also adds to the cost.

In order to develop the skills of the juniors of course you will need to spend time on training them and explaining things to them – again spending more time and money in the process.

The training and staff-development route is a much more positive and ultimately more cost-

Chapter One

Fundamental Principles and Strategy

Design businesses come in all shapes and sizes, from two-man bands to international organisations employing hundreds of people in several locations and encompassing many different disciplines – architecture, interior design, graphic design, product design, marketing and management.

Some are famous, some unheard of. Public awareness sometimes comes from size – large companies, particularly those quoted on the stock market, tend to receive greater attention and coverage in the media. Others make themselves known through their work – which may be unusual, extreme, or just highly regarded – or through personalities in the company who are either well known in their own right or very outspoken.

Each of these businesses has a strategy which gives them direction and guides them towards a particular kind of work, type of client, internal structure and external reputation. The strategy may have been consciously laid down at the very formation of the business or it may have grown gradually through a series of apparently accidental developments, which will in fact be the cumulative impact of the personalities and attitudes of those involved.

While there may be a danger in overplanning and overstructuring a design business, it would nevertheless be foolish to allow a business to drift aimlessly through a mist of uncertainty. In order to manage a business properly, you should identify your strategy (whether purposeful or organic) and recognise where it is likely to lead you.

Some fundamental alternatives are outlined below and these will be useful starting points in such an exercise.

QUALITY OR QUANTITY
As descriptions of the end-result of your labours, quality and quantity are not of course mutually exclusive, but there is no doubt that they often pull in opposite directions.

When you start you may have to take on work to pay the rent, but remember if you don't set

Contents

7	**Managing Yourself and Your Team** *97*	8	**Time Management** *116*
7.1	Self Management *97*	8.1	Attitudes *116*
7.2	Goal Setting *100*	8.2	Tools *119*
7.3	Team Management *103*	8.3	Techniques *121*
7.4	Development of Individuals and Teams *107*		
			Index *127*

Contents

1	**Fundamental Principles and Strategy** 7	4	**Starting a Business** 52	

2 **Marketing and Generating New Business** 11

2.1 Marketing and Design 11
2.2 Targetting by Sector 12
2.3 Building on your Strengths 15
2.4 Filling the Gaps 16
2.5 Be Prepared 17
2.6 Selling Techniques 18
2.7 Indirect Promotion 19
2.8 Building up your Portfolio 21

3 **Managing Projects and Clients** 24

3.1 The Contract 24
3.2 Terms of Business 27
3.3 Pitching 29
3.4 Royalties 31
3.5 Programme and Team Selection 32
3.6 Project Familiarisation 34
3.7 Educating the Client 36
3.8 Directing and Reviewing the Project 37
3.9 The Moment of Decision 39
3.10 Concept Presentation 40
3.11 Changes in the Teams 41
3.12 Keeping in Touch\ 43
3.13 Developing Client Relationships 46
3.14 The Second Sell 48

4 **Starting a Business** 52

4.1 Partners and Philosophy 52
4.2 Strengths and Weaknesses 54
4.3 An Order Book of Potential Business 55
4.4 What Type of Organisation? 56
4.5 Overheads 57
4.6 Finance 58
4.7 Value-Added Tax 60
4.8 PAYE, National Insurance and Pensions 61

5 **Managing a Design Business** 64

5.1 Financial Planning and Budgets 64
5.2 Project Control and Systems 70
5.3 Suppliers 74
5.4 Employing Staff 76
5.5 The Unforeseen and the Unfortunate 78
5.6 Critical Management Information 82

6 **Larger Companies** 89

6.1 Communications and Structure 89
6.2 Specialisation in Design 90
6.3 Specialisation in Marketing 91
6.4 Divisionalisation 93
6.5 Losing the Spice of Life 95

Architecture Design and Technology Press
128 Long Acre
London
WC2E 9AN

Copyright © Longman Group UK Limited 1989

All rights reserved; no part of this publication may be reproduced,
stored in a retrieval system, or transmitted in any form or by any means,
electronic, mechanical, photocopying, recording, or otherwise,
without the prior written permission of the Publishers.

First published 1989

British Library Cataloguing in Publication Data
A CIP catalogue record for this book is available from the British Library.

ISBN 1 85454 145 5

MANAGING A DESIGN PRACTICE

Richard Mott

Architecture Design and Technology Press
London

MANAGING A DESIGN PRACTICE

Dorothy A. Balmer
March '94